Art
Dog

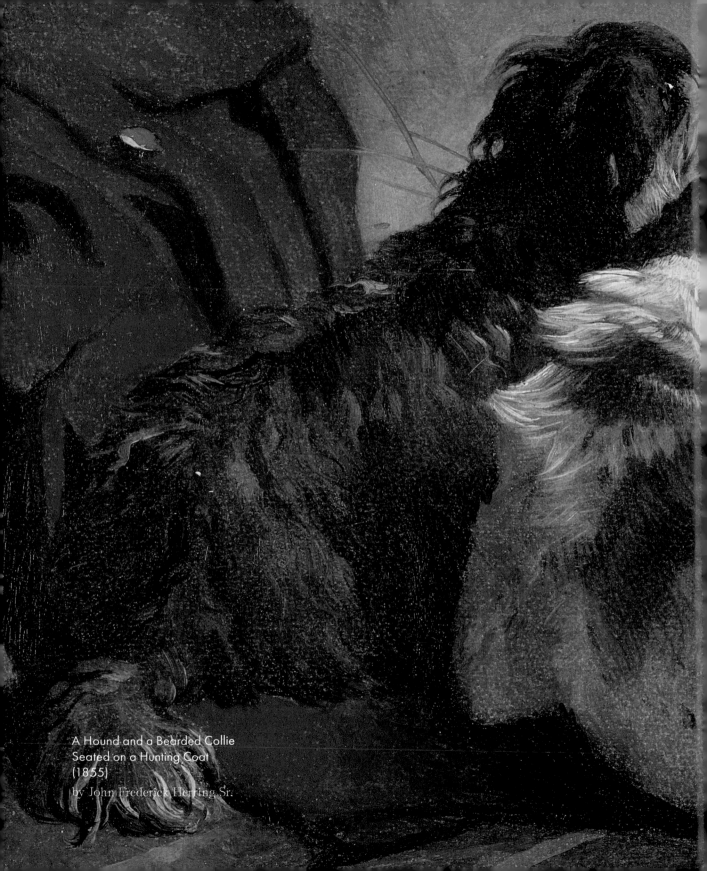

A Hound and a Bearded Collie
Seated on a Hunting Coat
(1855)
by John Frederick Herring, Sr.

Art
Dog

Clever Canines
of the Art World

Smith
Street
Books

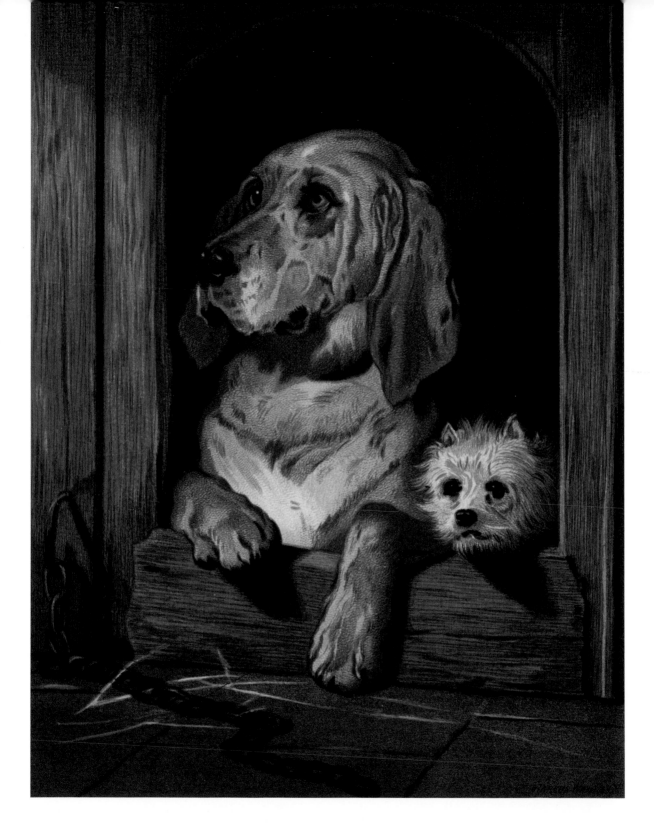

Introduction

While it may feel like our obsession with dogs is a recent phenomenon, hounds have played the role of humankind's best friends for somewhere around 15,000 years. We have been breeding them and making a record of their companionship and antics for millennia.

As you paw your way through the following pages, you will find dogs depicted in sculpture, oils, charcoal, watercolours, engravings and daguerreotypes. Whatever the medium, canines of all shapes and sizes are celebrated here, by artists from across history and around the globe.

Depending on how deeply invested you are in notions of realism, some works may appeal to you more than others. But as a joyous collection, these pieces serve as indisputable proof that a love of dogs is a near-universal experience.

LEFT
Dignity and Impudence
(1877)
by Sir Edwin Landseer

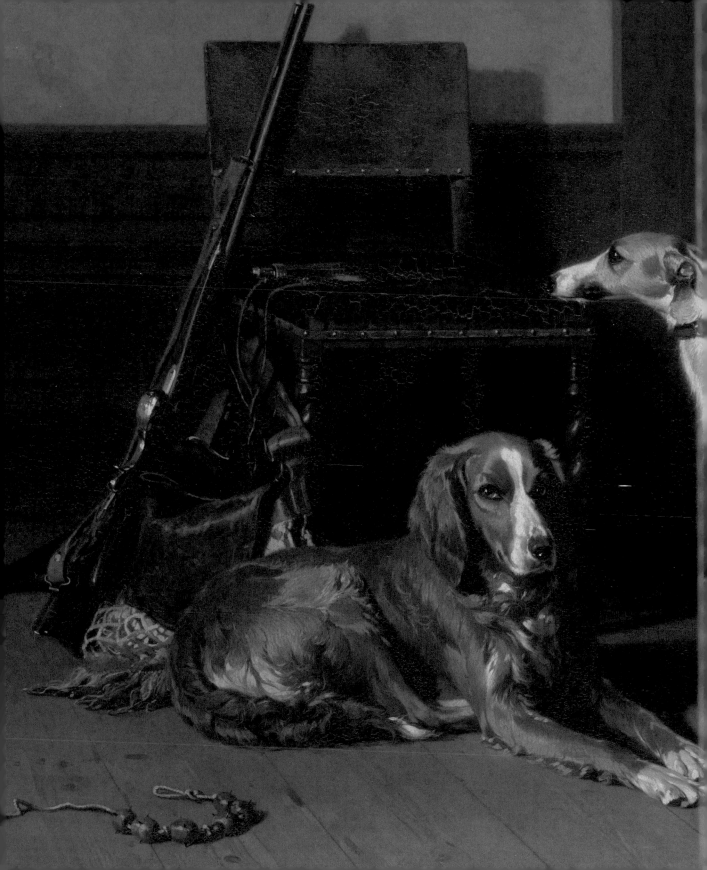

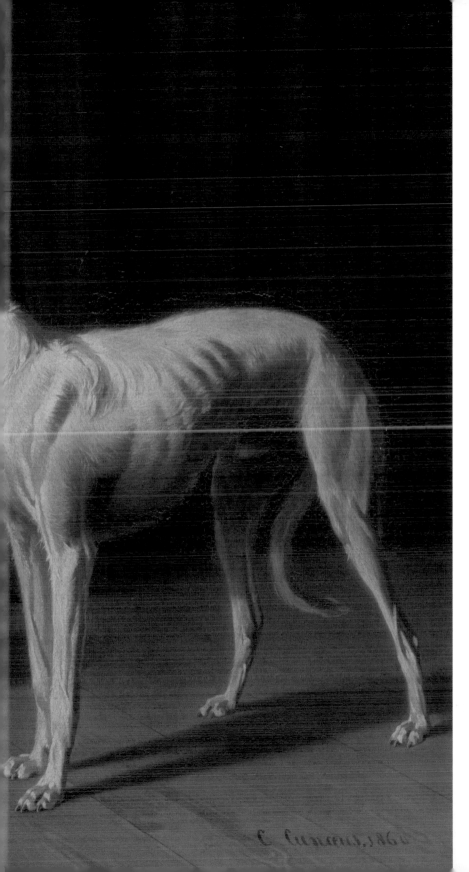

Hunting Companions
(1860)

by Conradijn Cunaeus

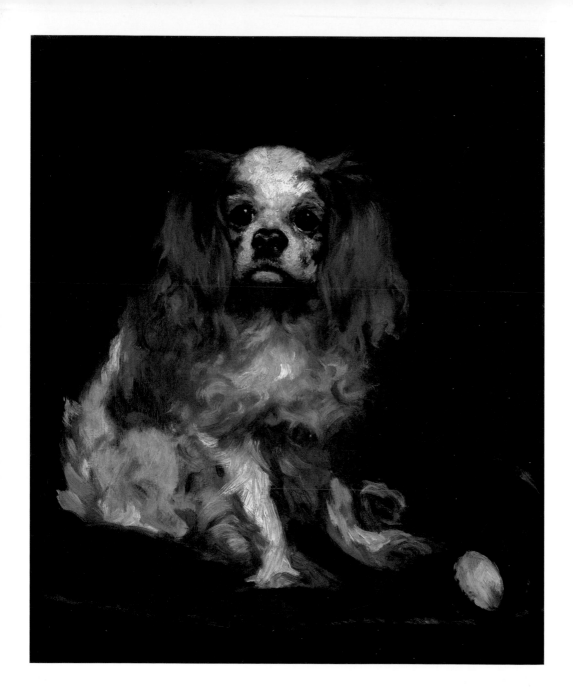

ABOVE
A King Charles Spaniel
(ca. 1866)

by Édouard Manet

RIGHT
Dog Studies
(n.d.)

by August Specht

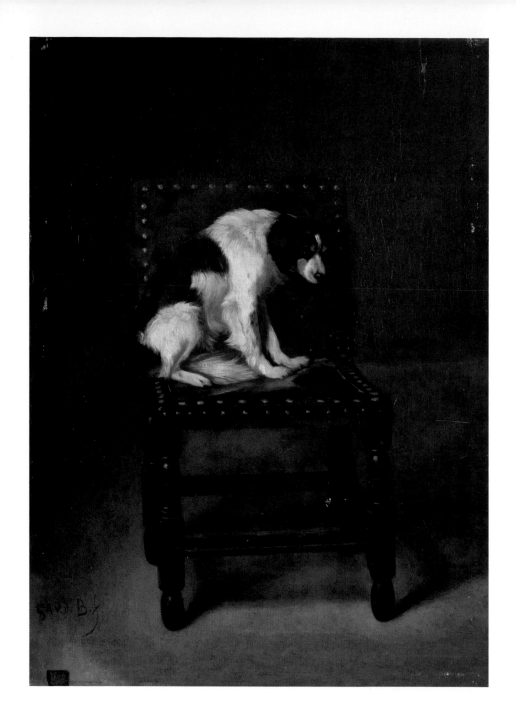

A Dog on a Chair
(1860–1891)

by Guillaume Anne
van der Brugghen

Terrier Seated
(1861–1897)

by Frances Townsend

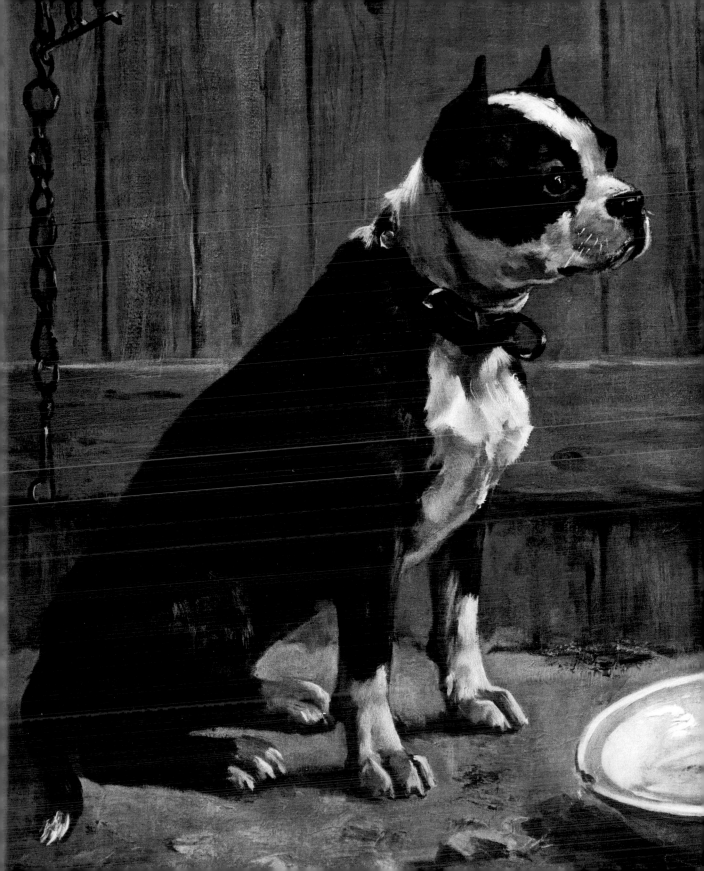

On the Trail
(1889)

by Winslow Homer

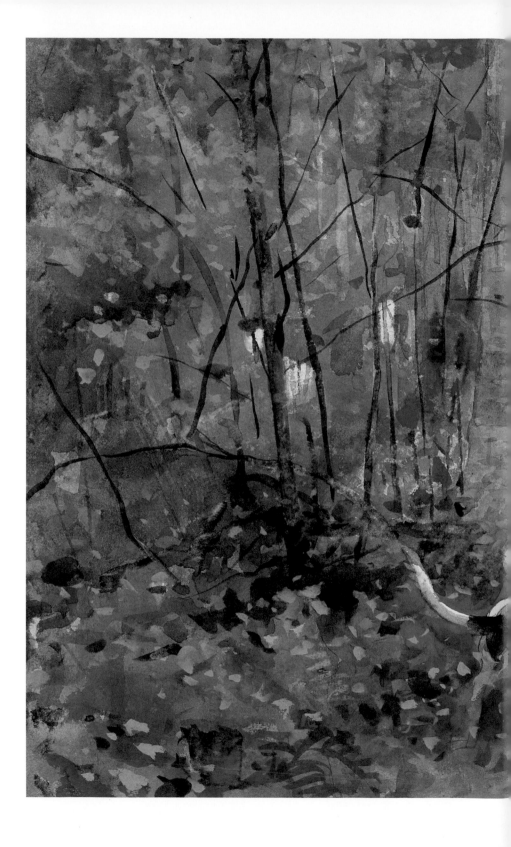

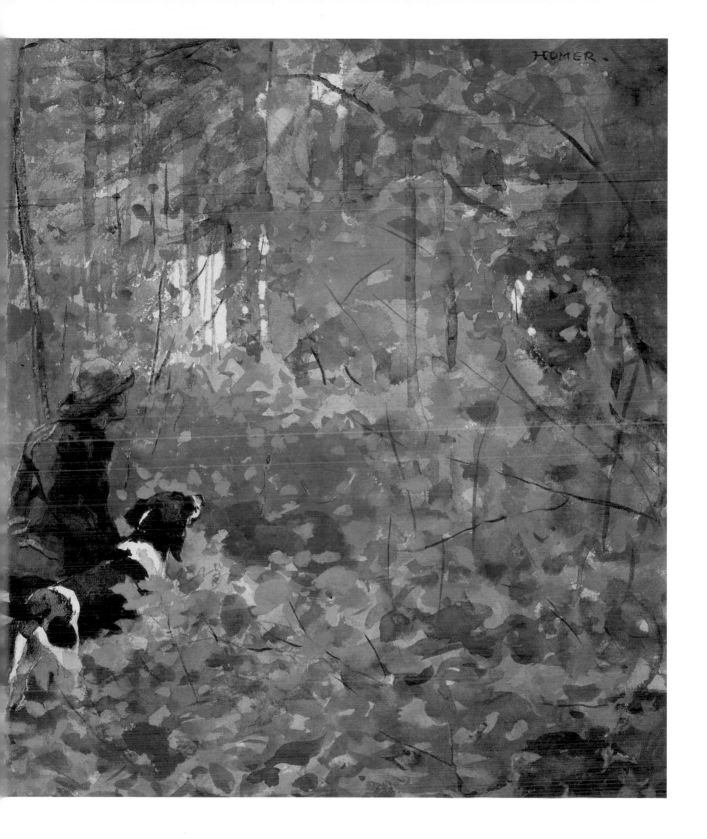

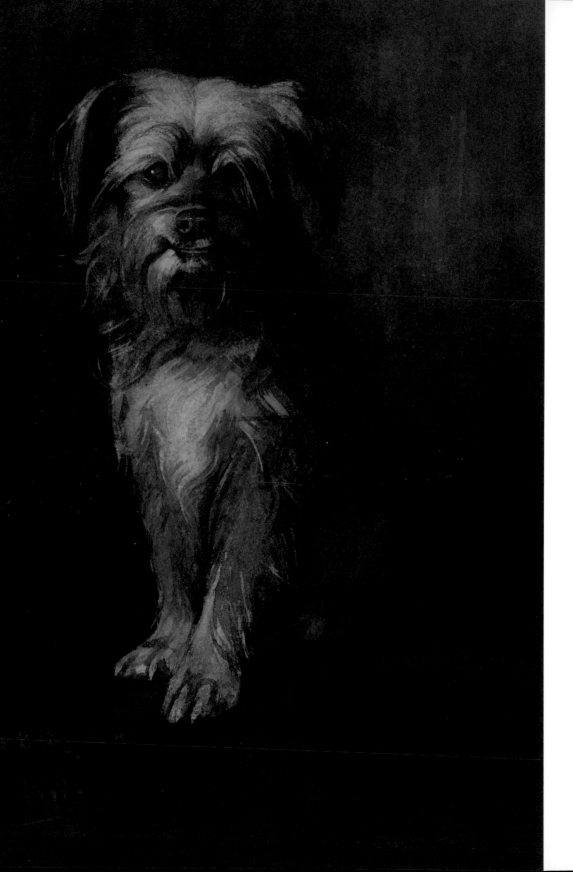

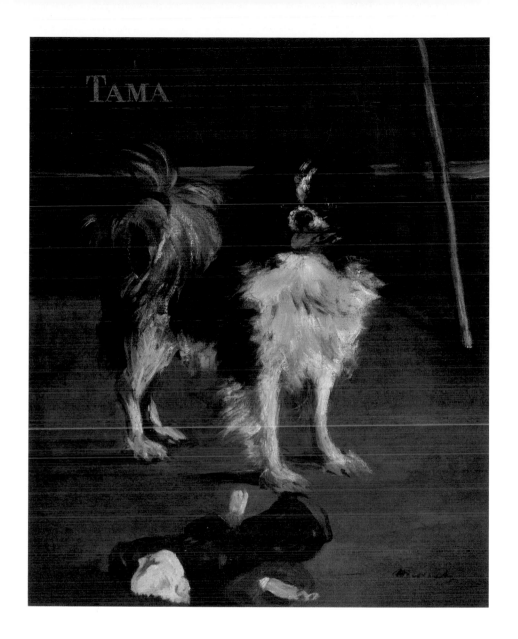

Tama, the Japanese Dog
(ca. 1875)
by Édouard Manet

Portrait of the Dog Phoebus
(1884)
by Willem Witsen

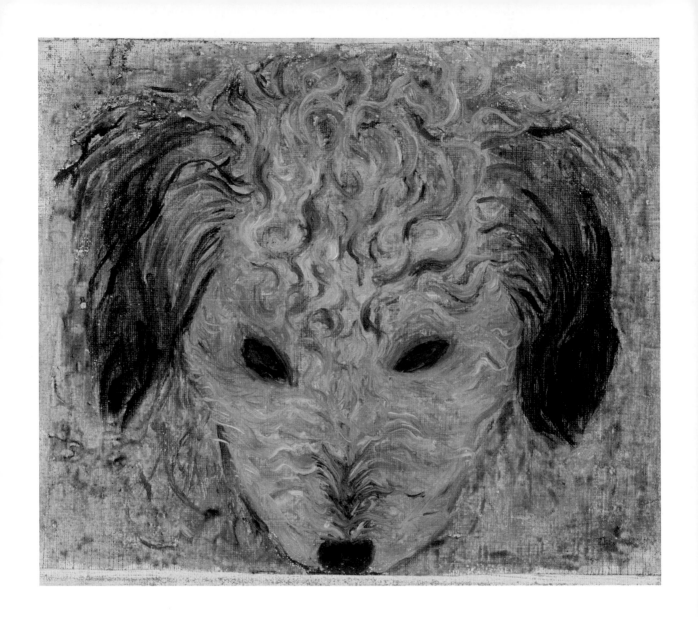

ABOVE
Dog's Head
(1932)

by Tadeusz Makowski

RIGHT
Dog
(ca. 1995)

by Andrzej Fornelski

16

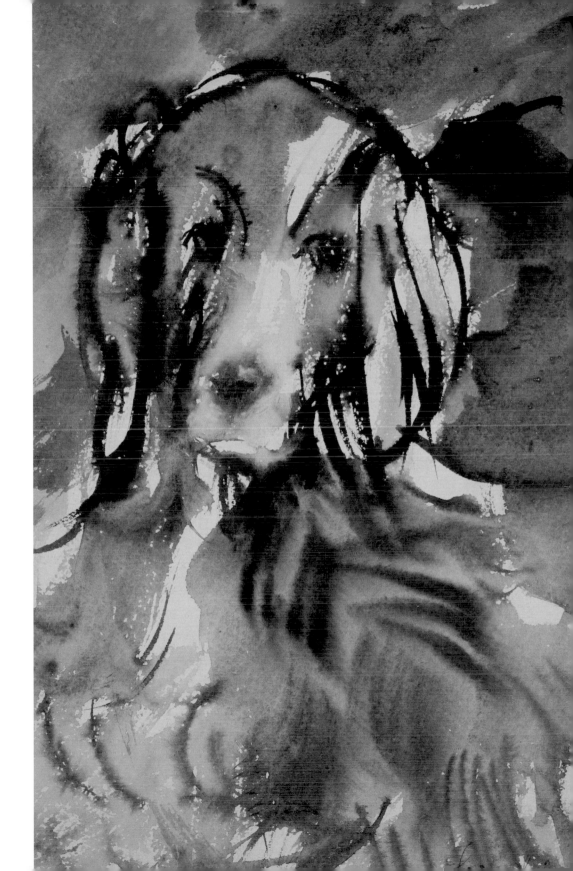

Study of a Dog
(1860s)

by Rosa Bonheur

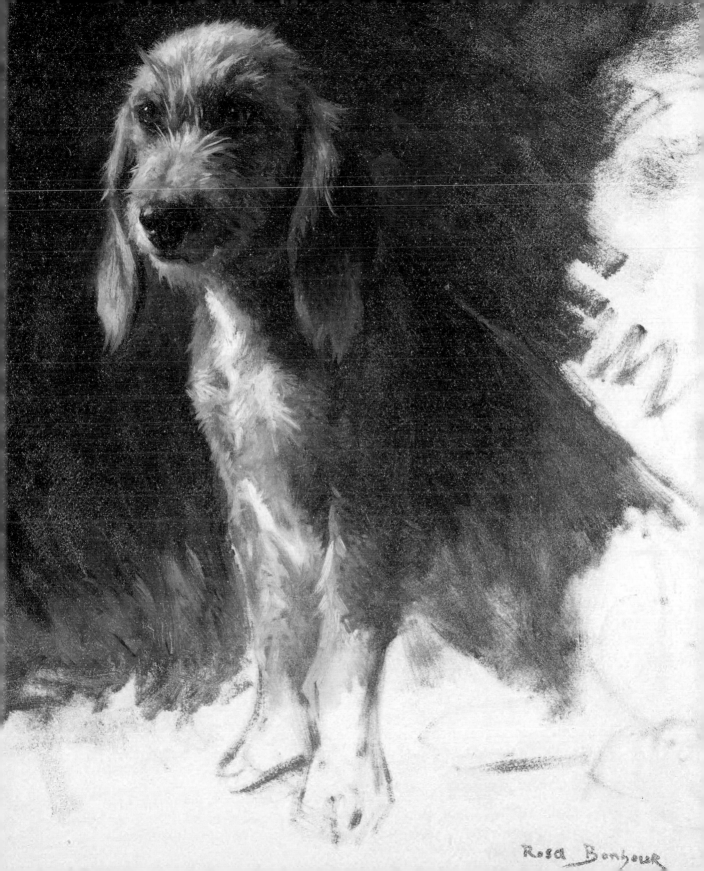

Rosa Bonheur

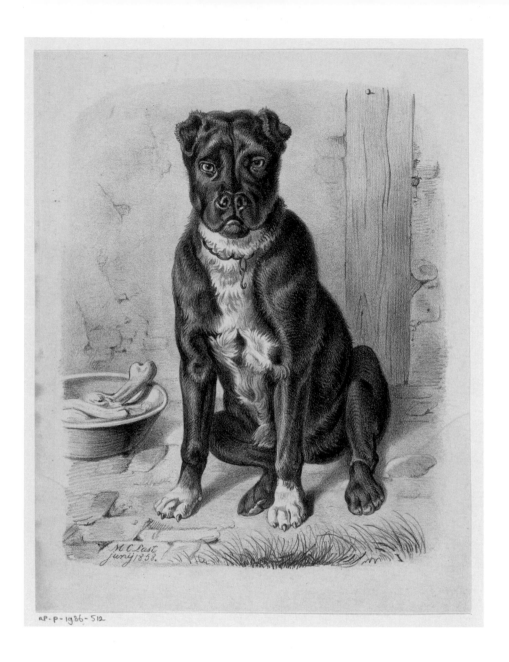

RP-P-1936-512

Hond naast etensbak
(1858)

by Maria Cristina Last

The Dog whose Ears were Cropped
(1900)

by Percy J. Billinghurst

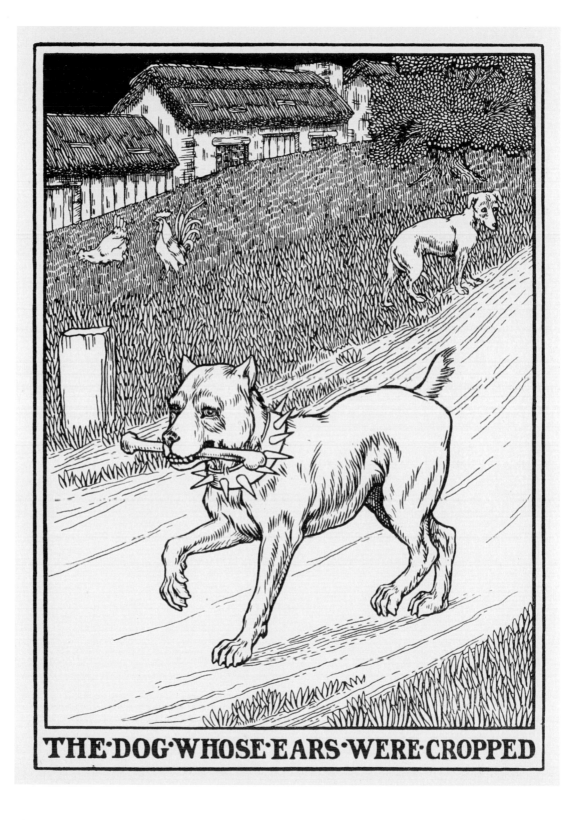

THE·DOG·WHOSE·EARS·WERE·CROPPED

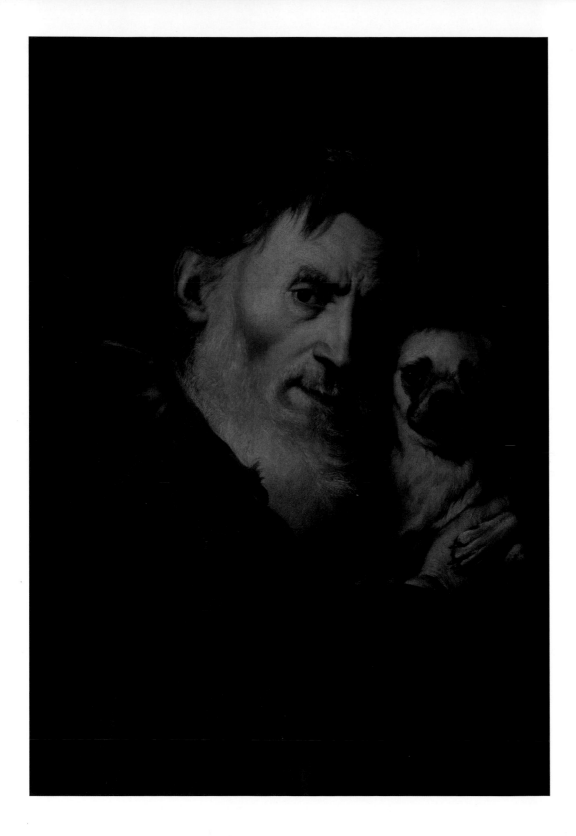

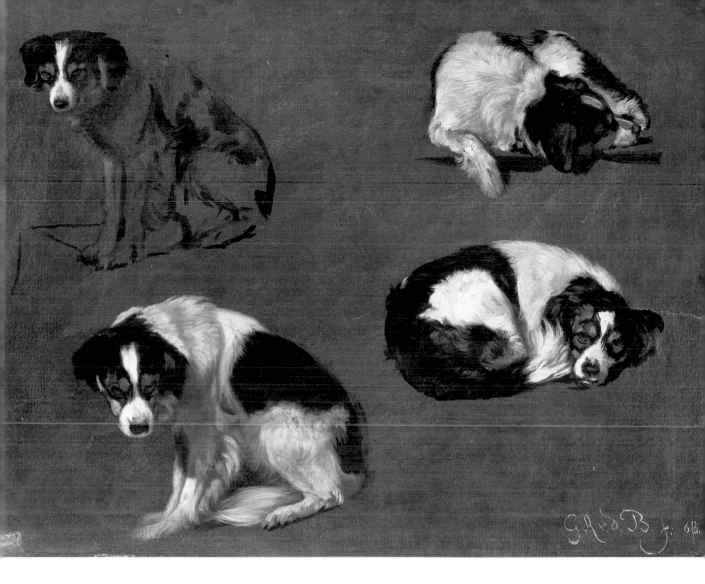

Four Studies of a Dog
(1868)

by Guillaume Anne
van der Brugghen

An Old Man with a Dog
(ca. 1740s)

by Giacomo Ceruti

23

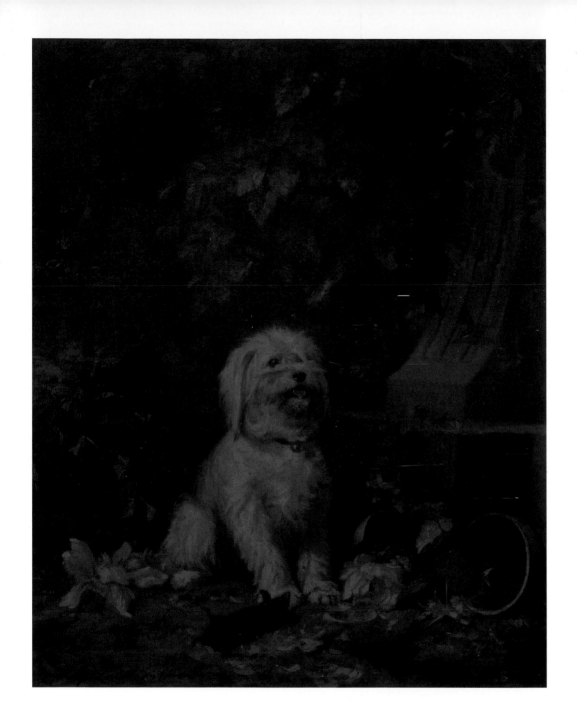

Dog with a Dead Mole
(1860)
by Louis-Eugène Lambert

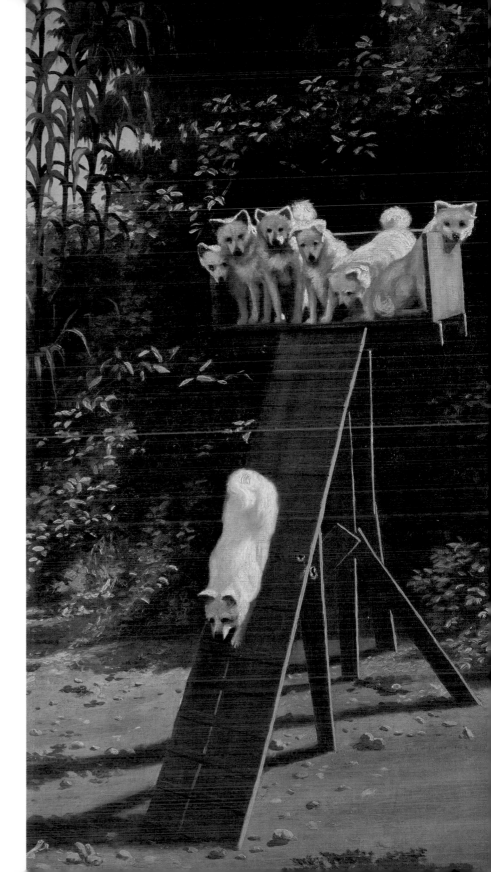

RIGHT
Dog Training
(1914)
by Andrew Putnam Hill

NEXT PAGE
Dog Lying in the Snow
(ca. 1911)
by Franz Marc

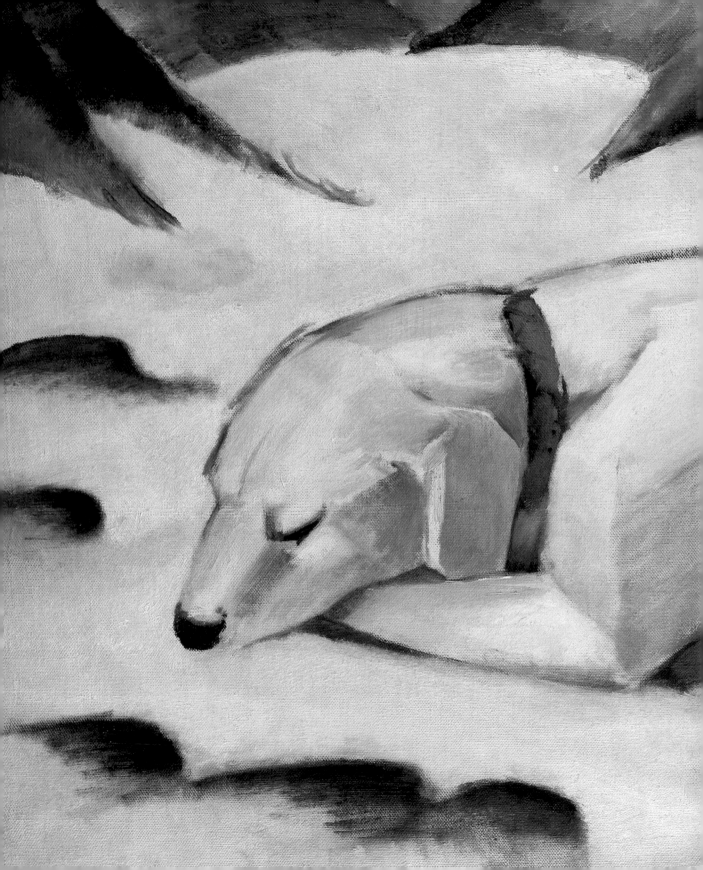

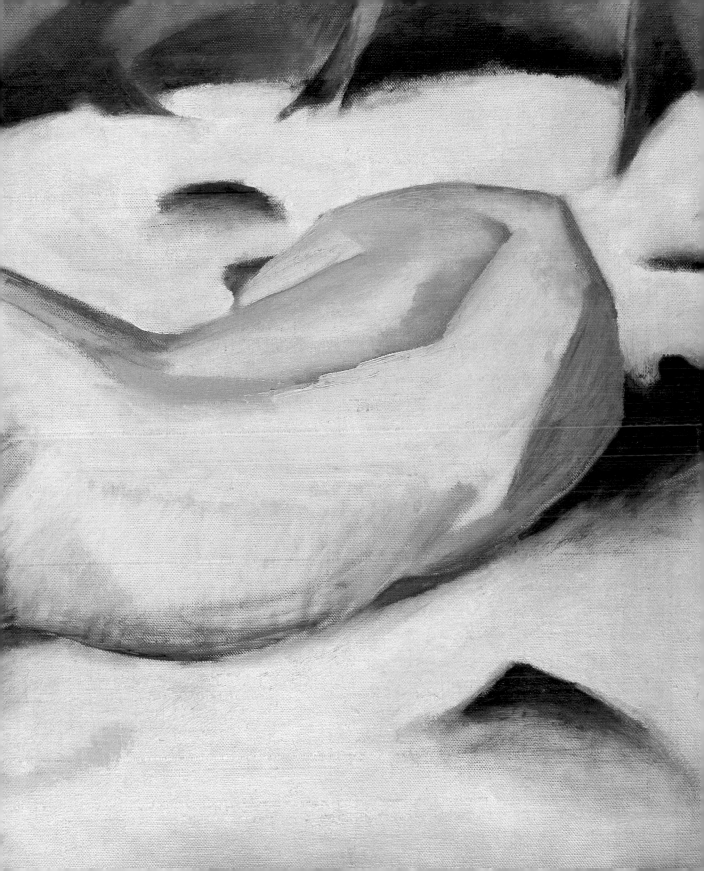

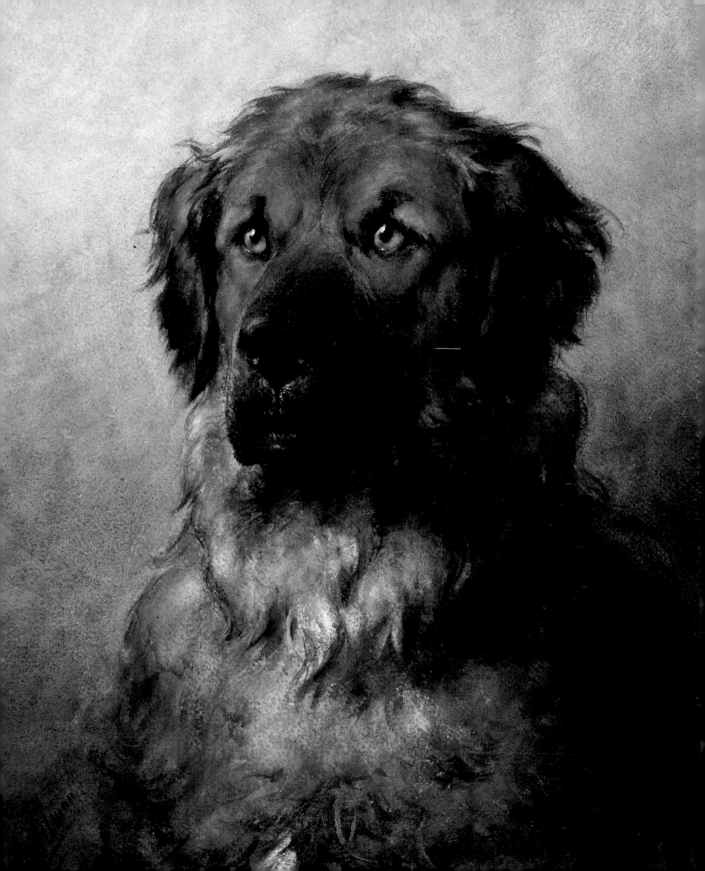

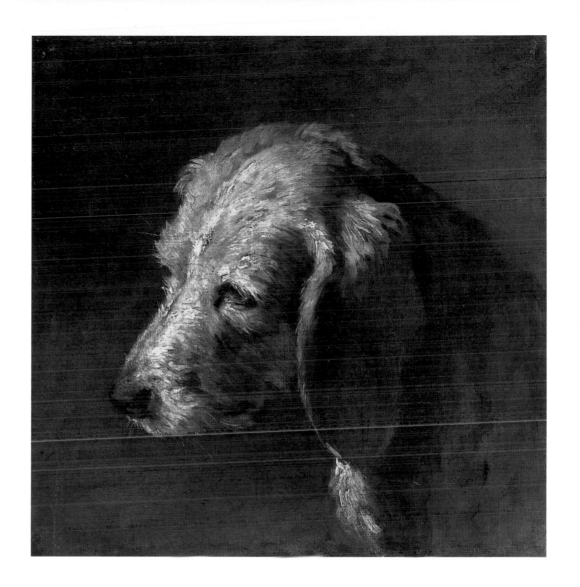

Head of a Dog
(ca. 1820)
attributed to Nicolas
Toussaint Charlet

LEFT
Head of a Leonberger
(1880–1892)
by Otto Eerelman

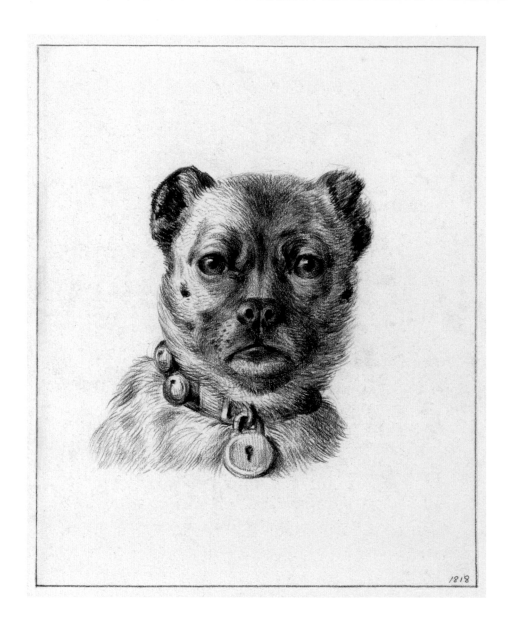

1818

ABOVE
Dog Head with a Collar
(1818)

by Jean Bernard

RIGHT
Cees, portret van een hond
(1912)

by Dick Ket

30

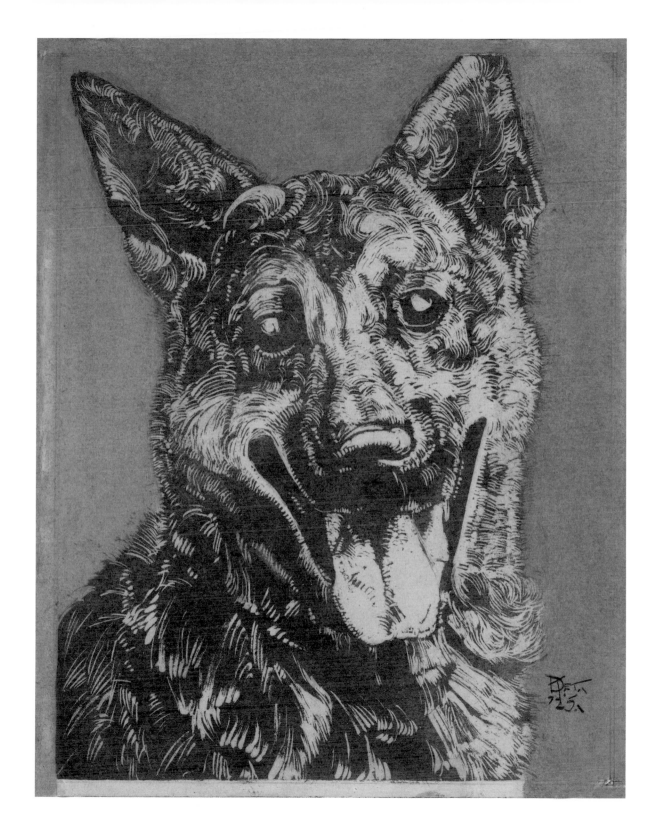

A Deerhound
(1826)
by Sir Edwin Henry Landseer

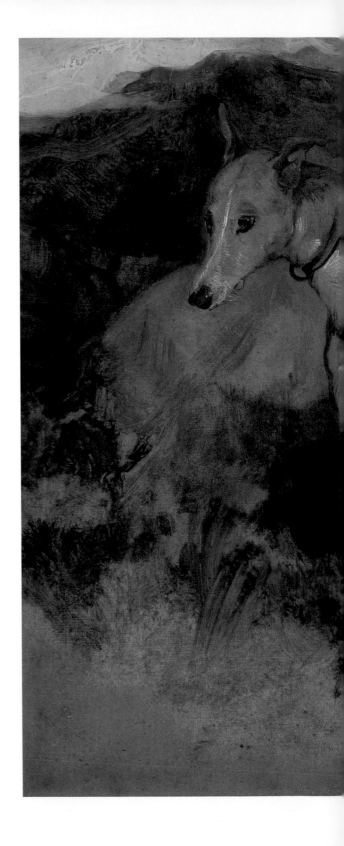

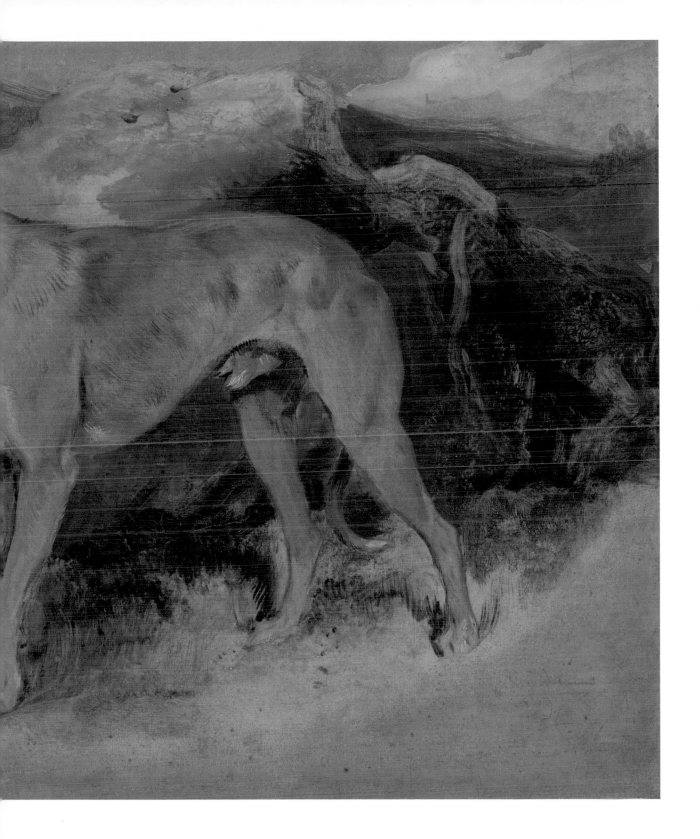

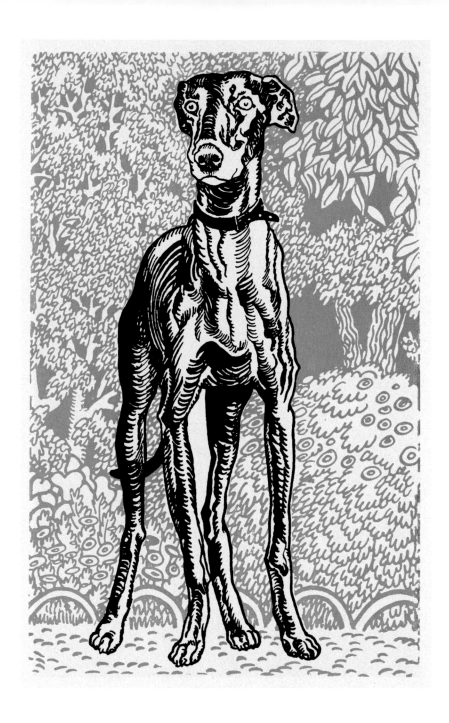

Greyhound
(1912)

by Moriz Jung

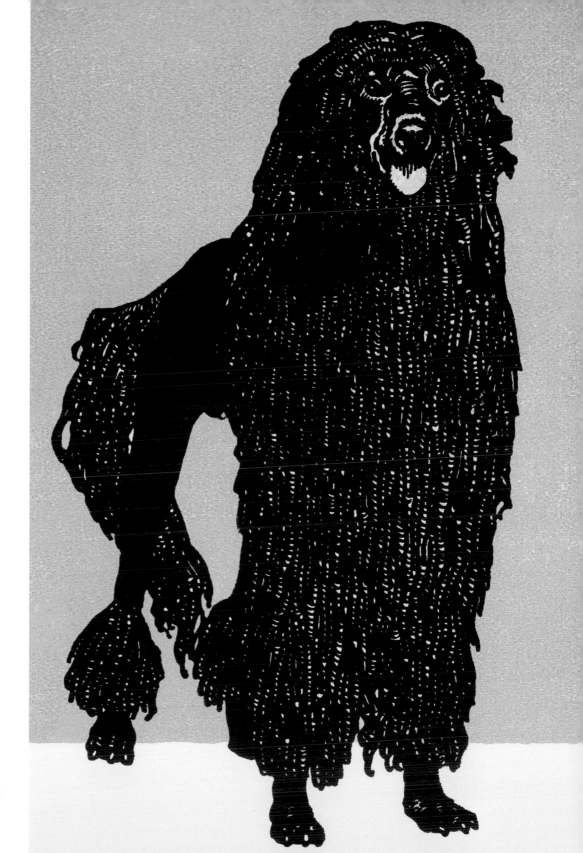

Poodle
(1912)
by Moriz Jung

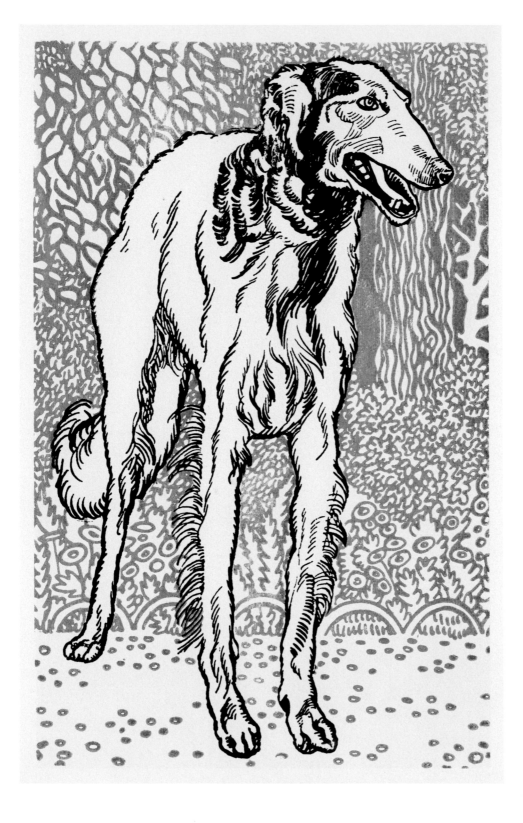

Greyhound
(1912)
by Moriz Jung

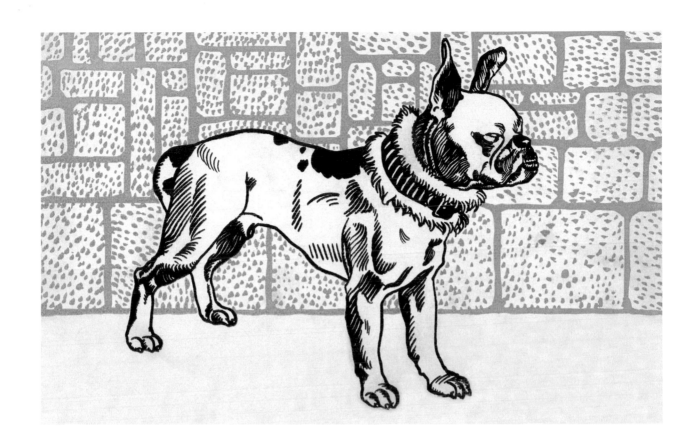

Pitbull Terrier
(1912)

by Moriz Jung

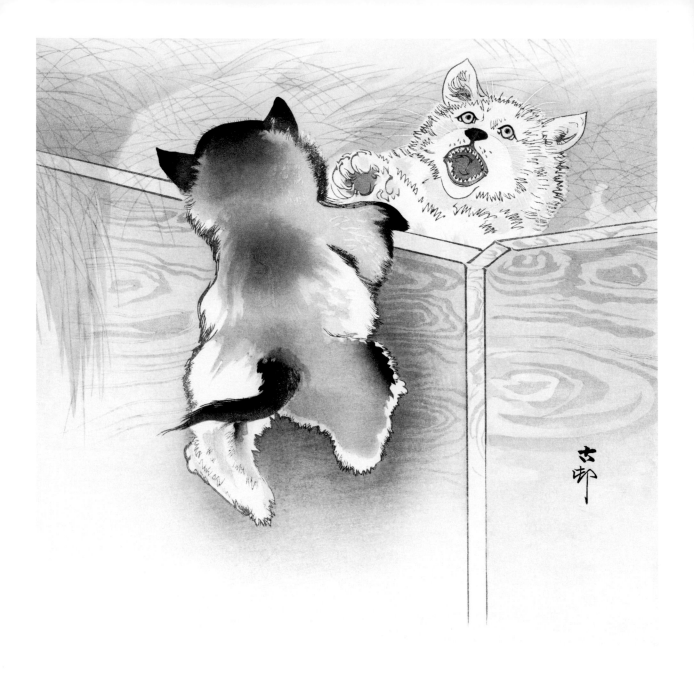

Two Playing Dogs
(1900–1930)

by Ohara Koson

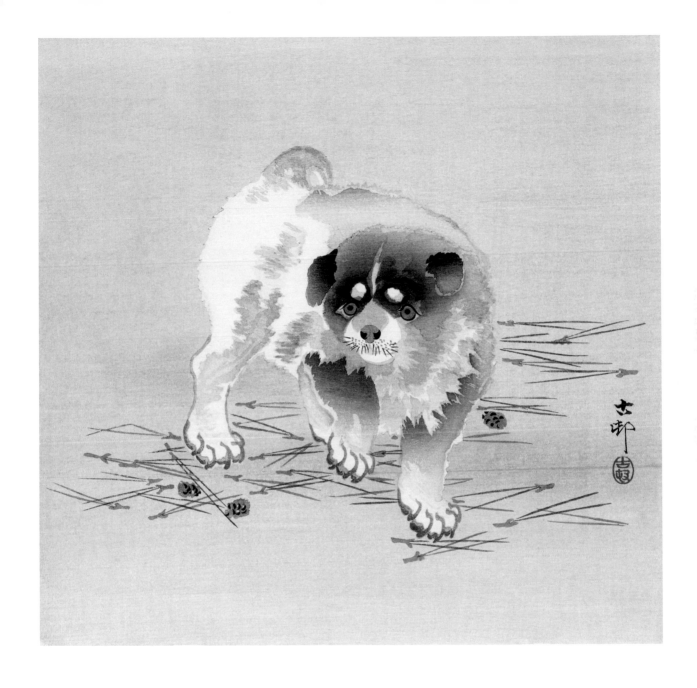

Young Dog
(1900–1930)

by Ohara Koson

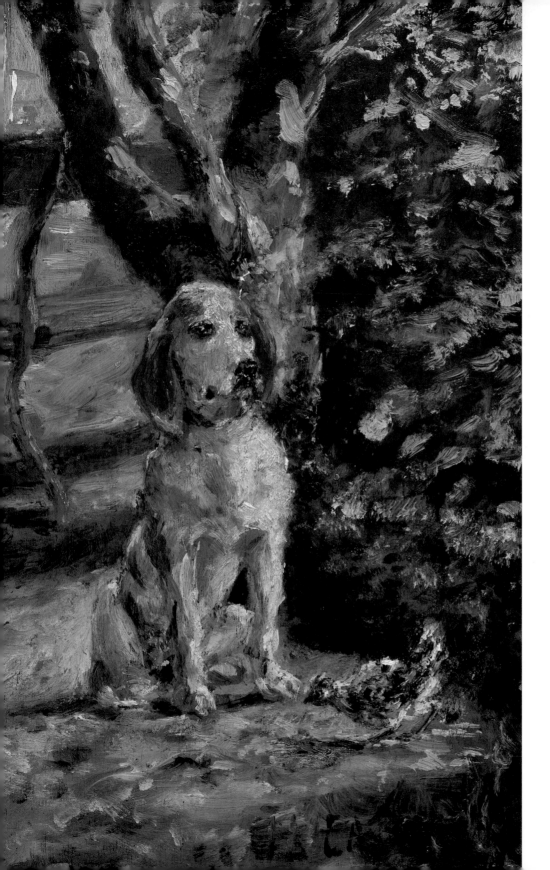

The Artist's Dog
Flèche
(ca. 1881)

by Henri de
Toulouse-Lautrec

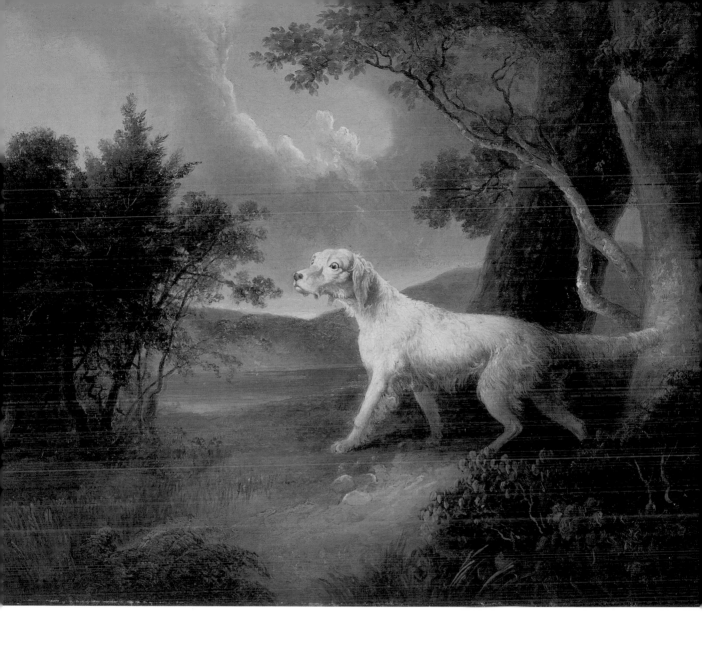

Landscape with Dog
(1832)

by Thomas Doughty

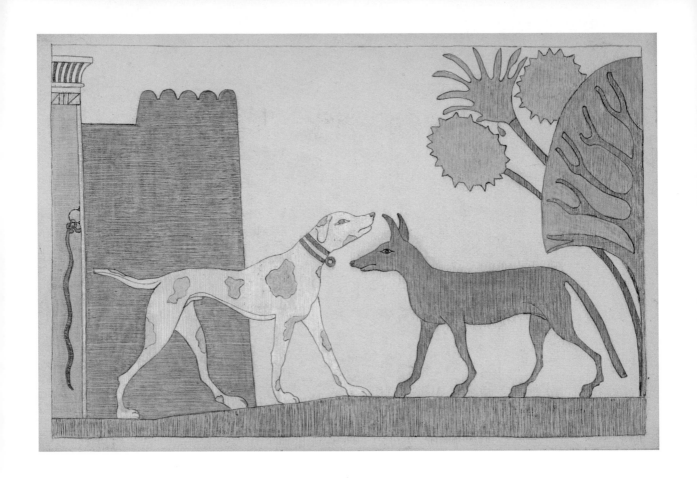

ABOVE
The Dog and the Wolf,
Illustration for Aesop's Fables
(ca. 1916)

by Victor Wilbour

RIGHT
Still Life with Three Puppies
(1888)

by Paul Gauguin

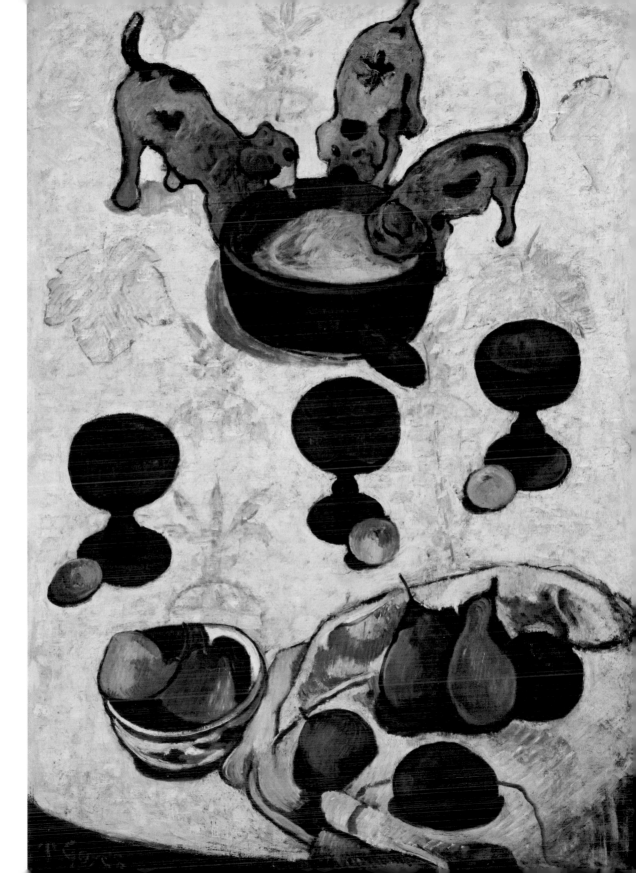

Carousel Dog
(ca. 1939)
by Dorothy Handy

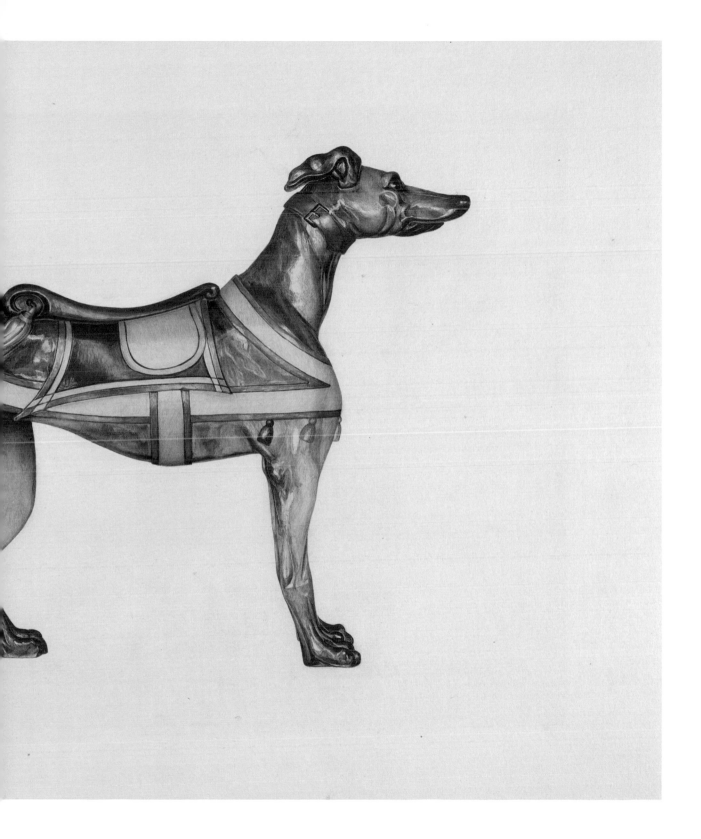

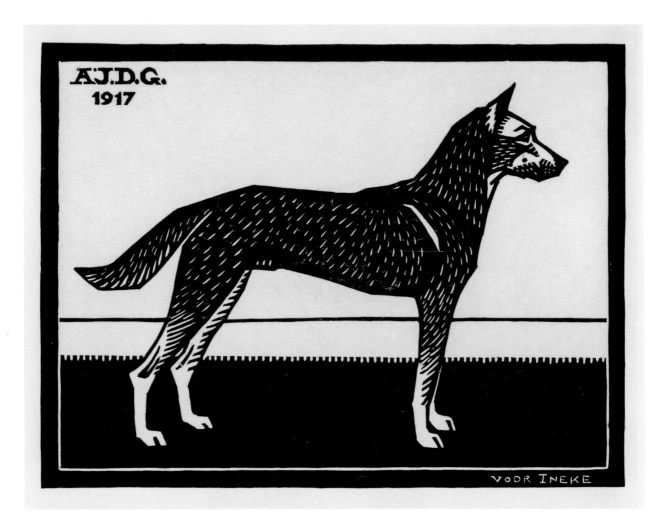

Dog
(1917)

by Julie de Graag

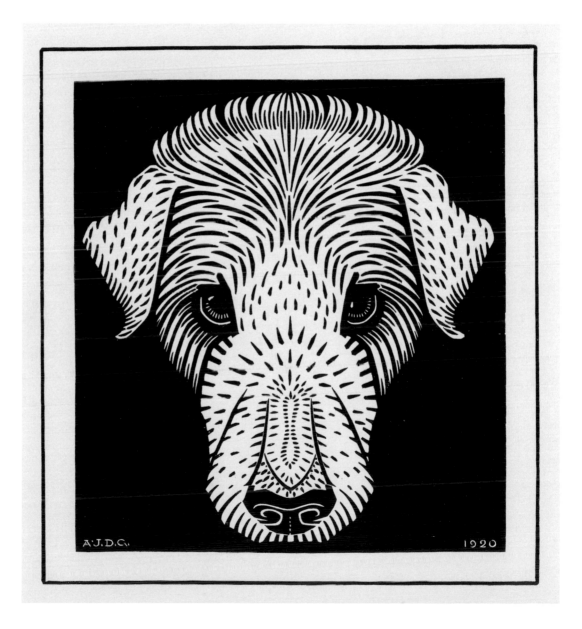

Arearea
(1892)

by Paul Gauguin

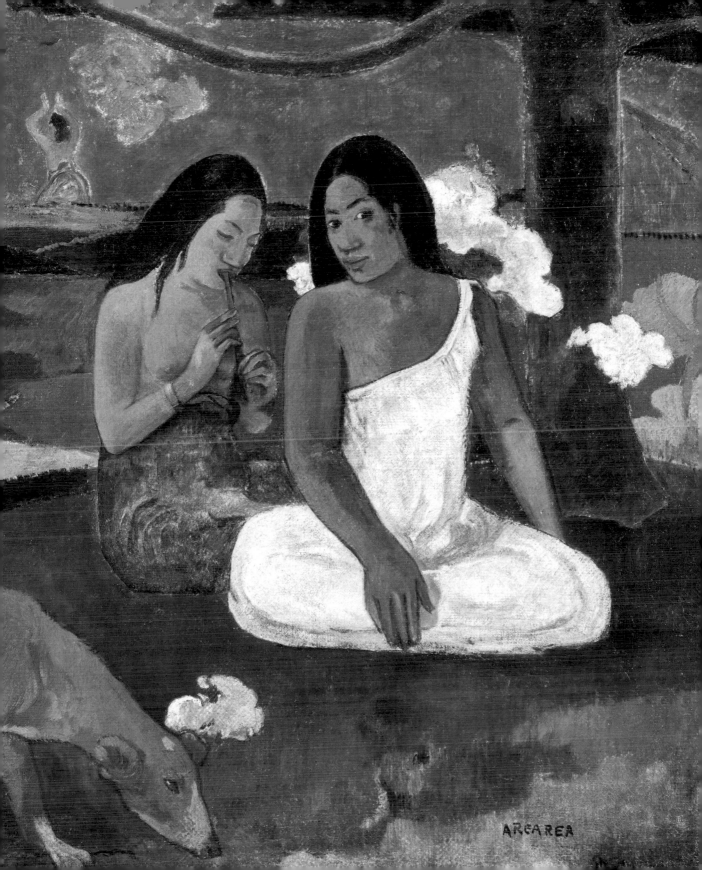

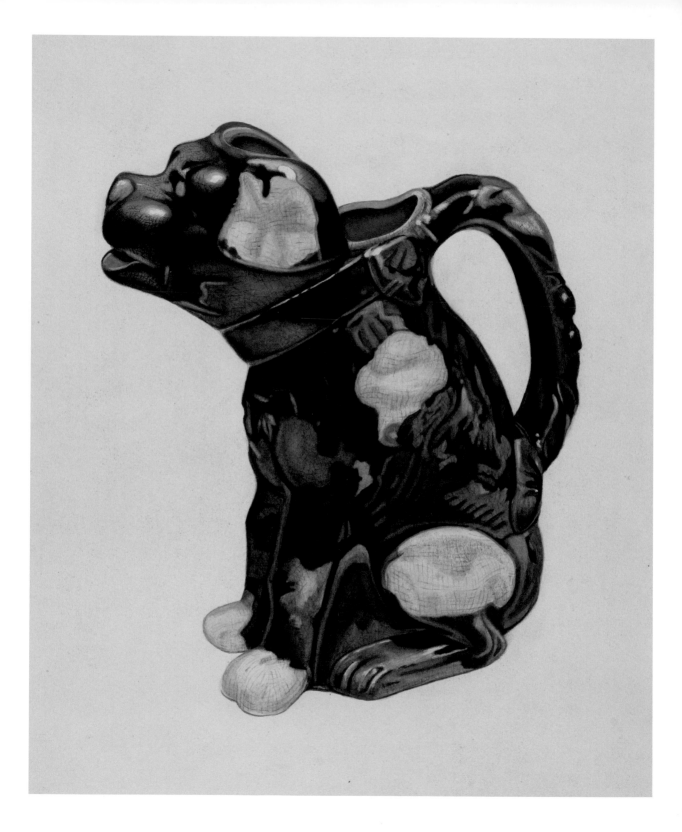

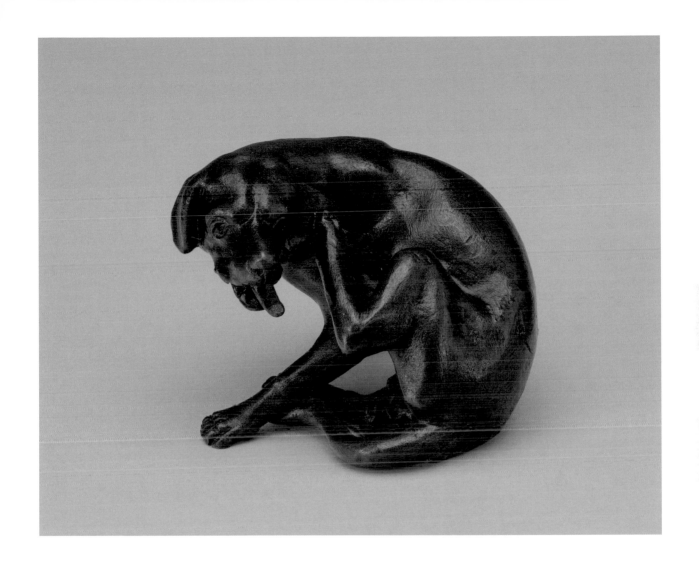

Dog Pitcher
(ca. 1938)

by Ernest A. Towers Jr.

A Dog Scratching
(ca. 1630)

attributed to Georg Schweigger

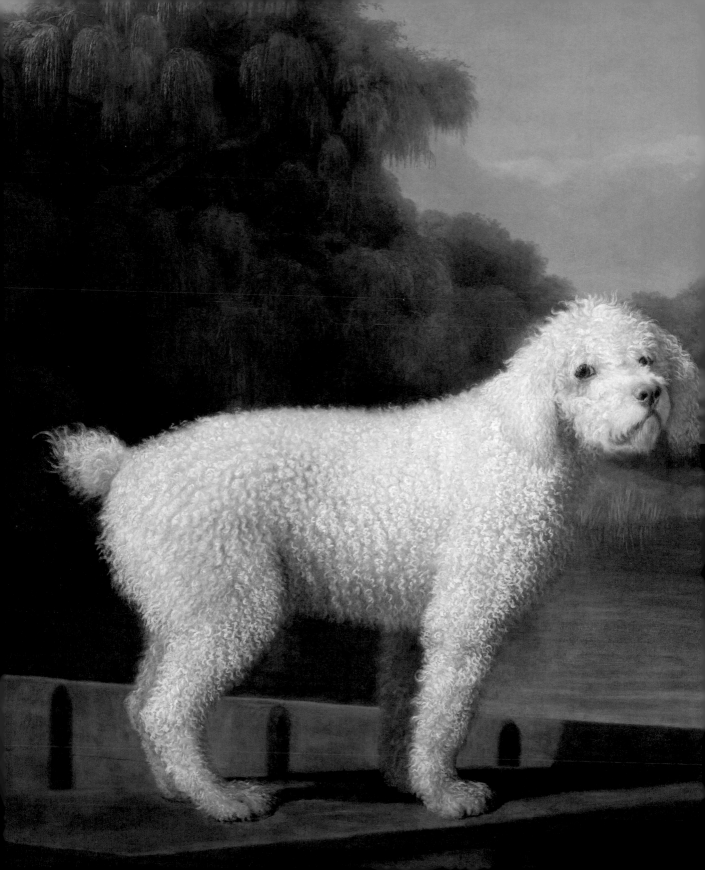

White Poodle in a Punt
(ca. 1780)
by George Stubbs

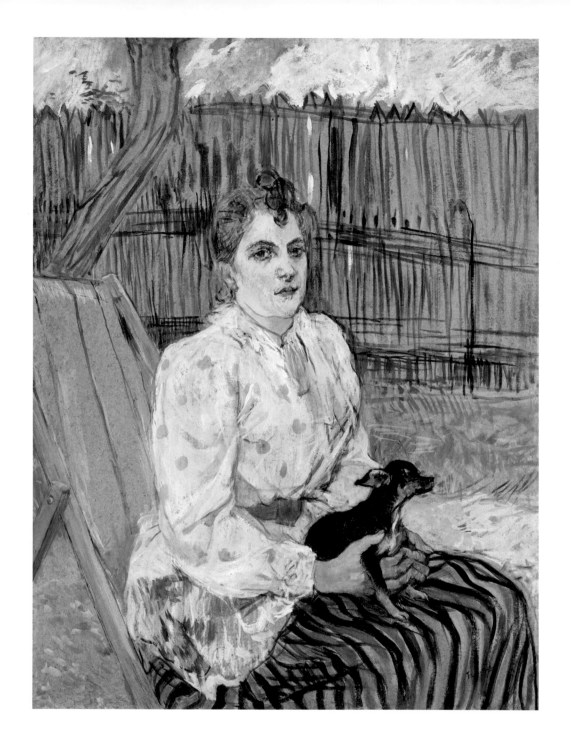

Lady with a Dog
(1891)

by Henri de Toulouse–Lautrec

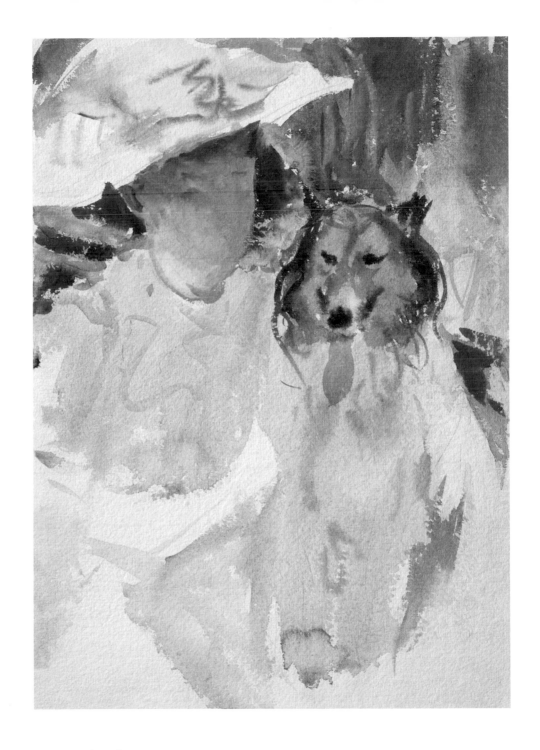

Woman with Collie
(after 1890)

by John Singer Sargent

Pottery Dog Ornament
(ca. 1938)

by Cleo Lovett

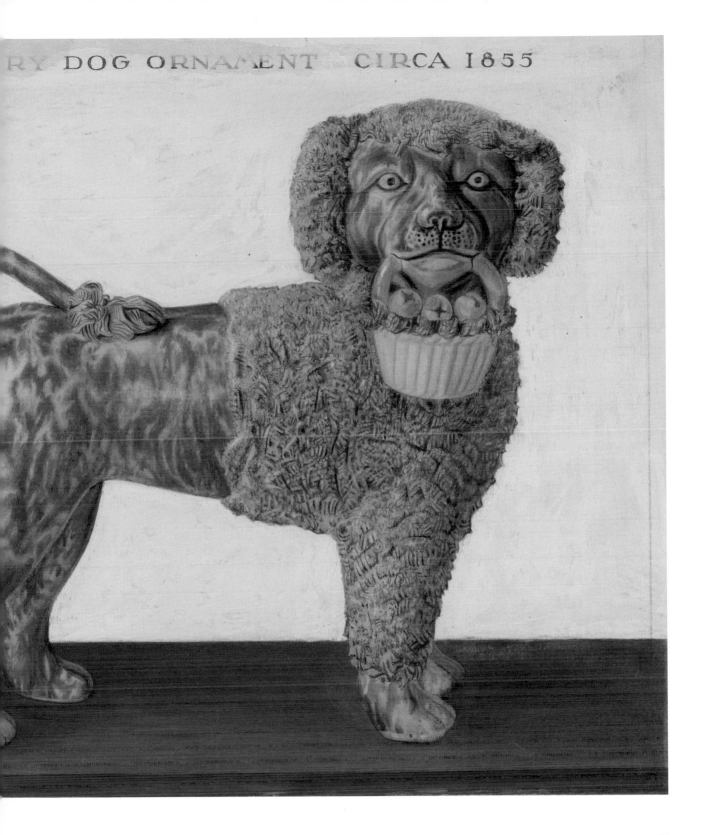

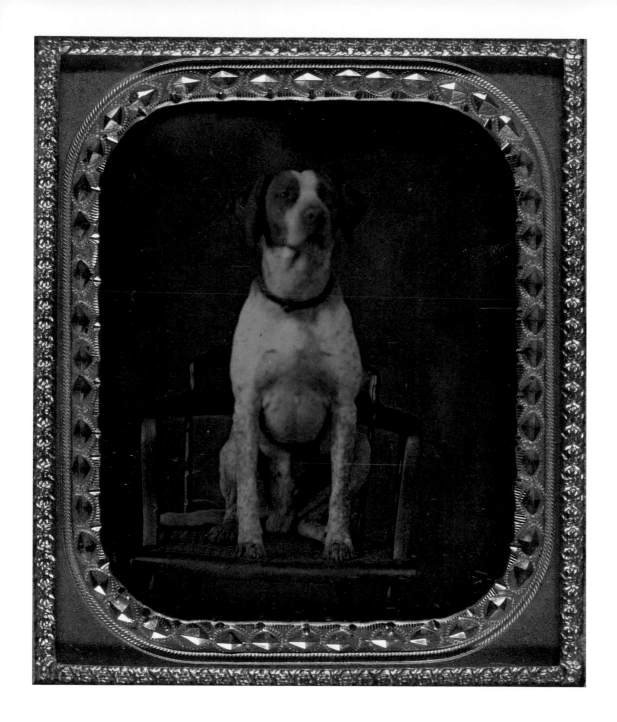

[Dog Posing for Portrait in
Photographer's Studio Chair]
(ca. 1855)

by Rufus Anson

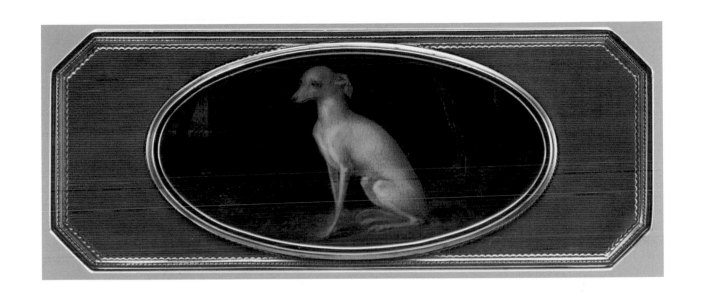

Box with Portrait of a Whippet
(ca. 1790)

attributed to Joseph
Etienne Blerzy

Suspense
(1877)
by Sir Edwin Landseer

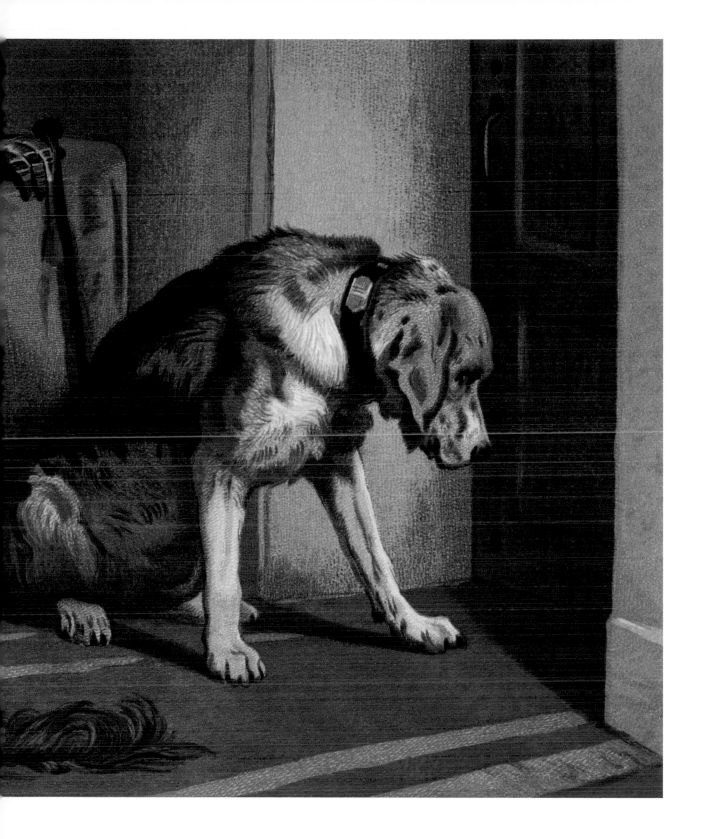

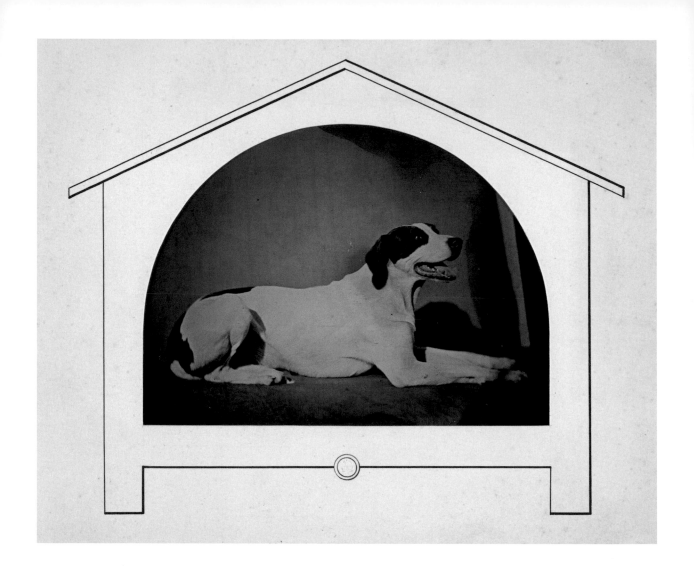

[Dog]
(1841–1849)

by Louis-Auguste Bisson

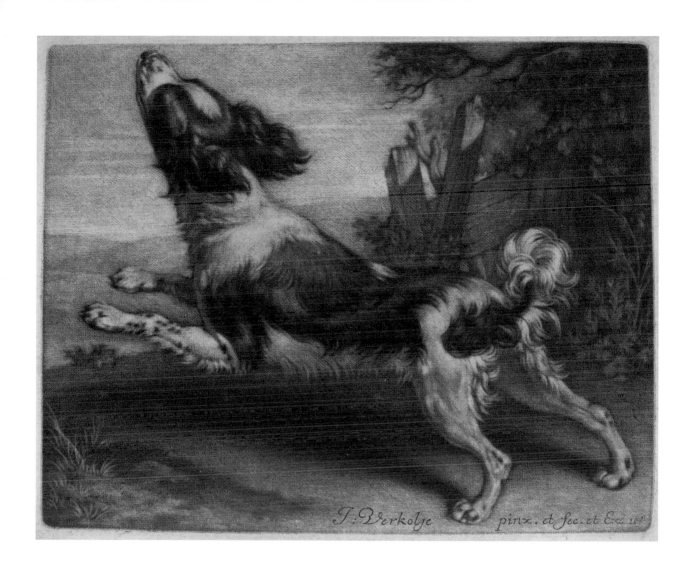

A Spaniel Jumping
(1680)

by Jan Verkolje I

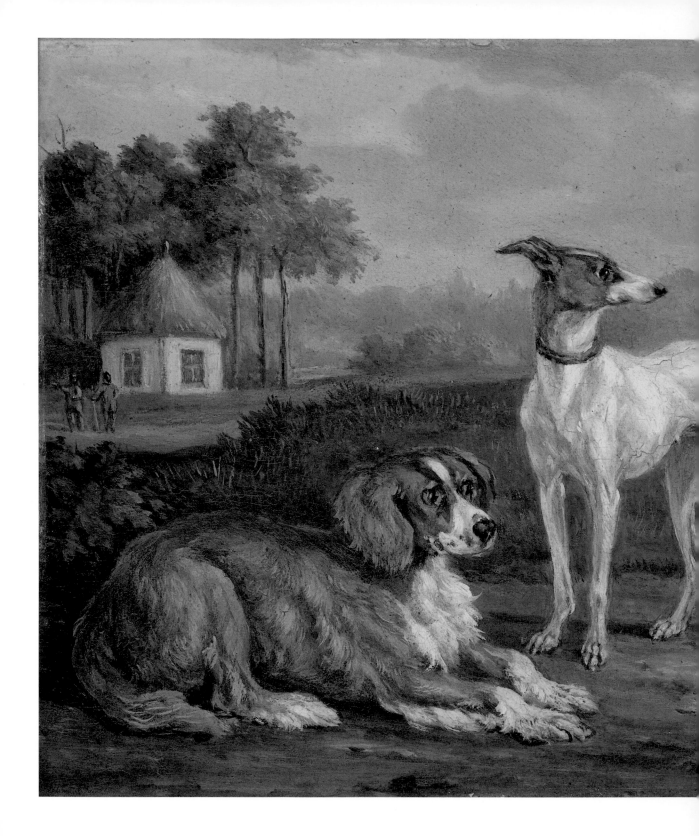

Two Dogs
(1810–1855)
by Jan Dasveldt

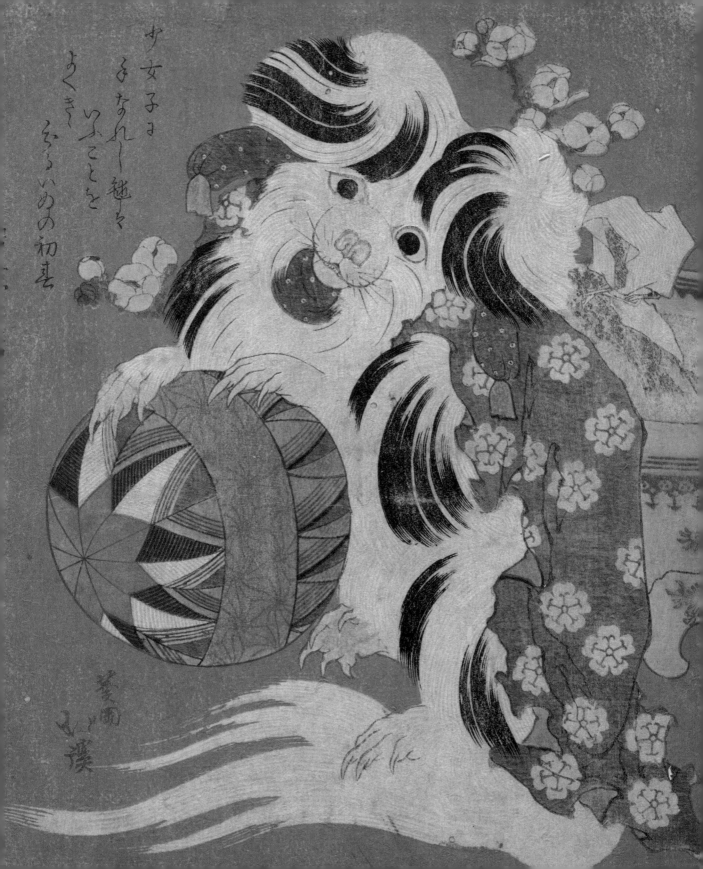

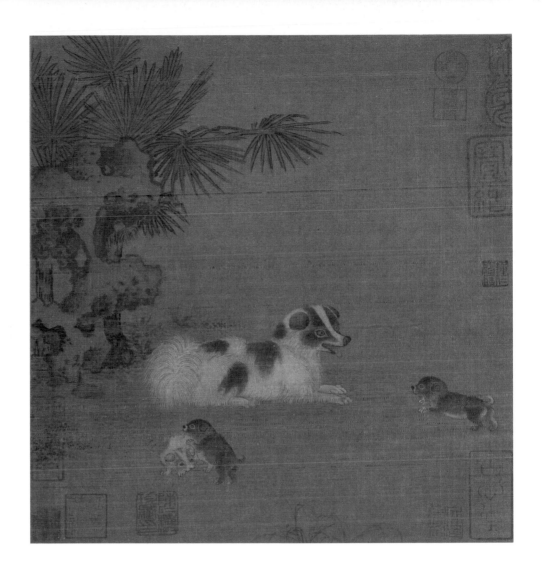

Puppies Playing Beside
a Palm Tree and Garden
Rock
(ca. 1400s)
by unidentified artist

Surimono Calendar
for the Dog Year, 1814
(1814)
by Totoya Hokkei

Juno
(ca. 1837)
by Nathaniel Currier

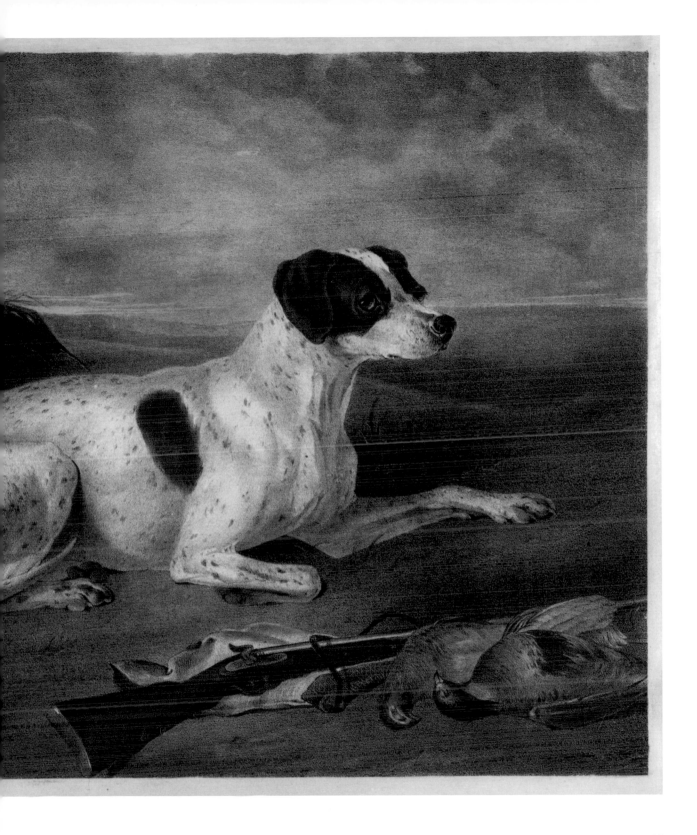

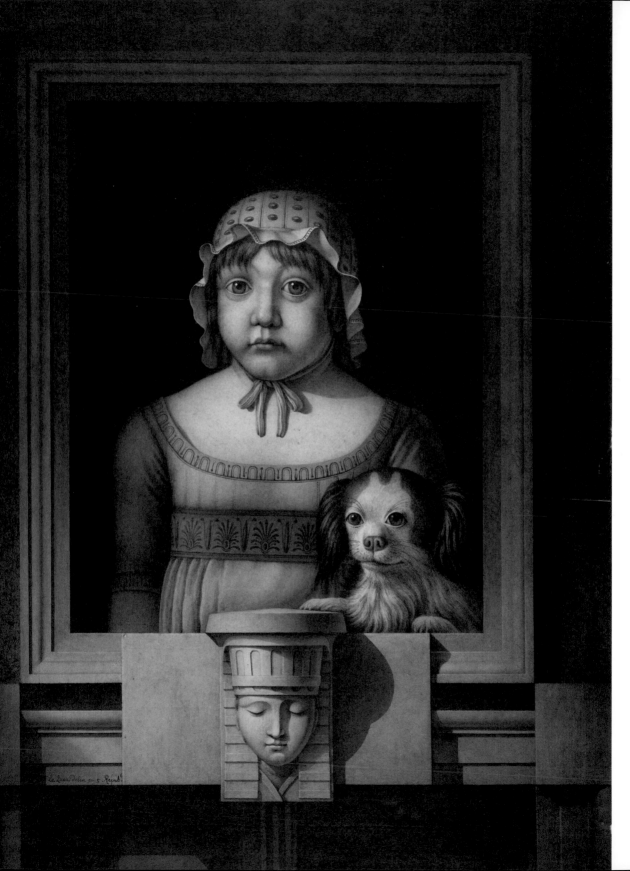

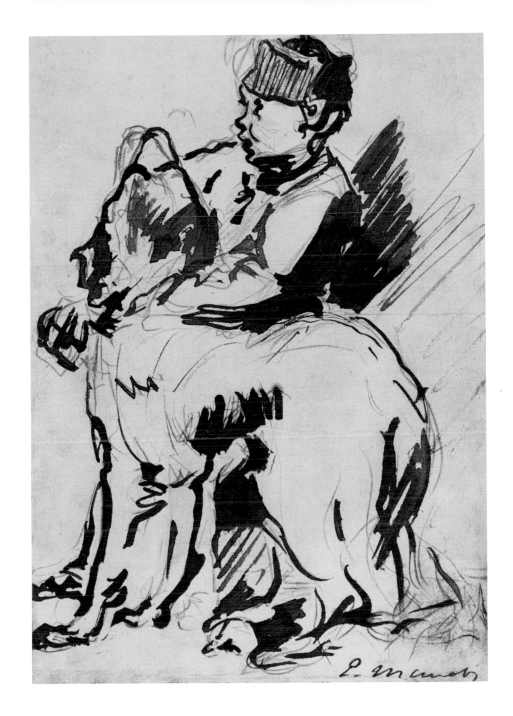

The Dog Request
(1854)

by Bernard te Gempt

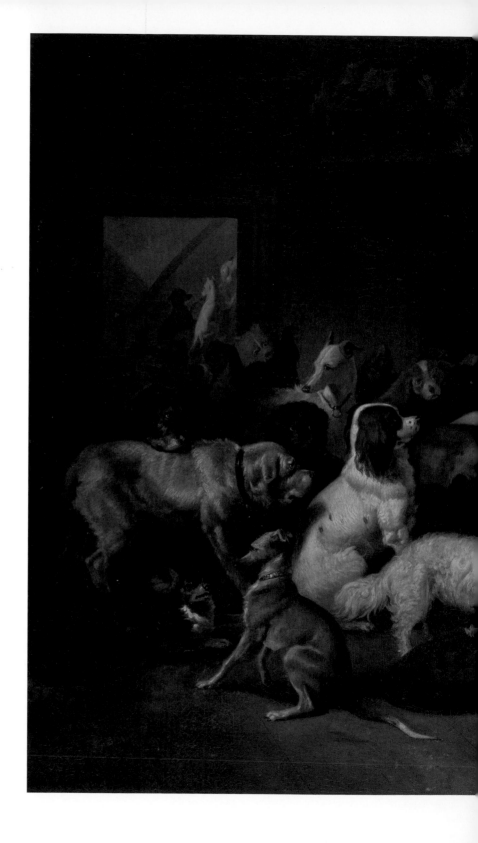

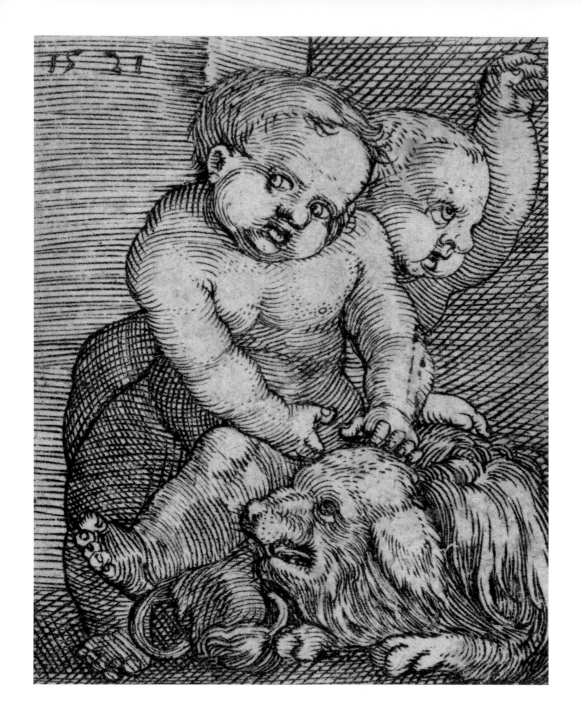

Two Boys Playing with a Dog
(ca. 1550s)

by Barthel Beham

A Large Chained Dog Howling
While Puppies Try to Climb
Onboard a Sinking Dog House
(1856)

by Miguel Pacheco

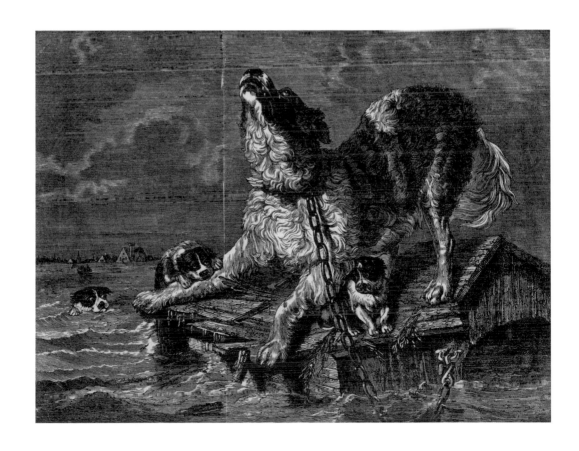

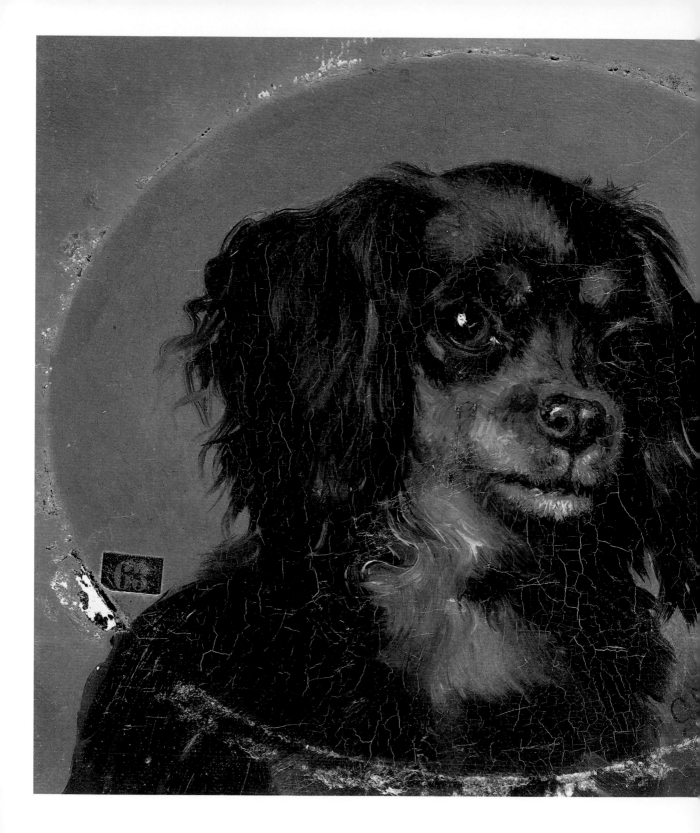

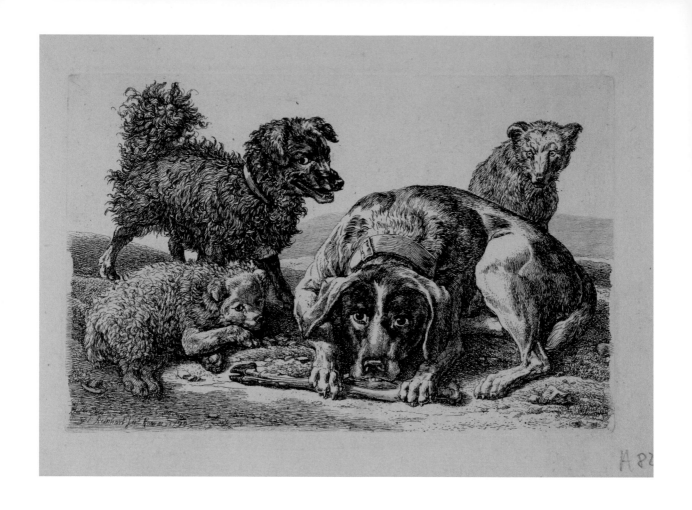

Four Dogs, from Die Zweite Thierfolge
(1799–1803)

by Johann Christian Reinhart

RIGHT
Vries, Frederik de (died 1613) Son of the Painter
Dirck de Vries, Pupil of Goltzius, with Goltzius's Dog
(1597)

by Hendrick Goltzius

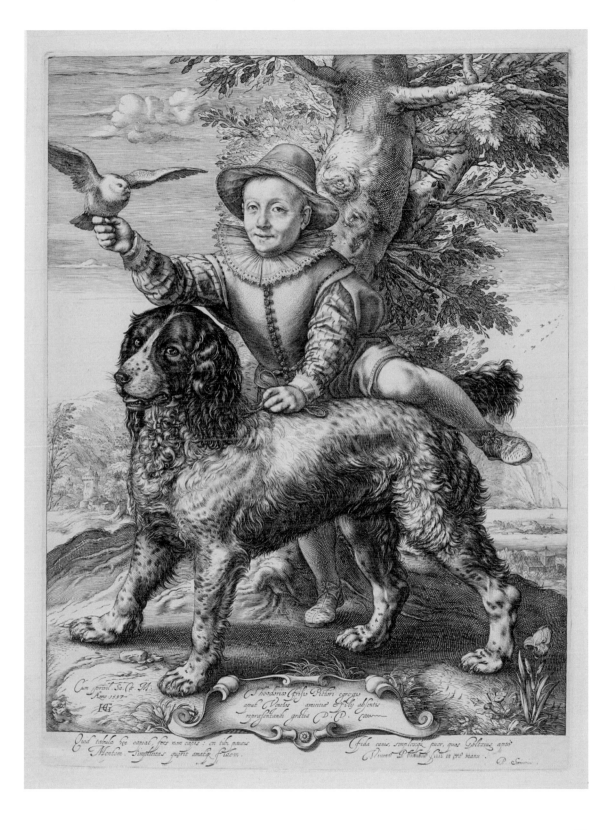

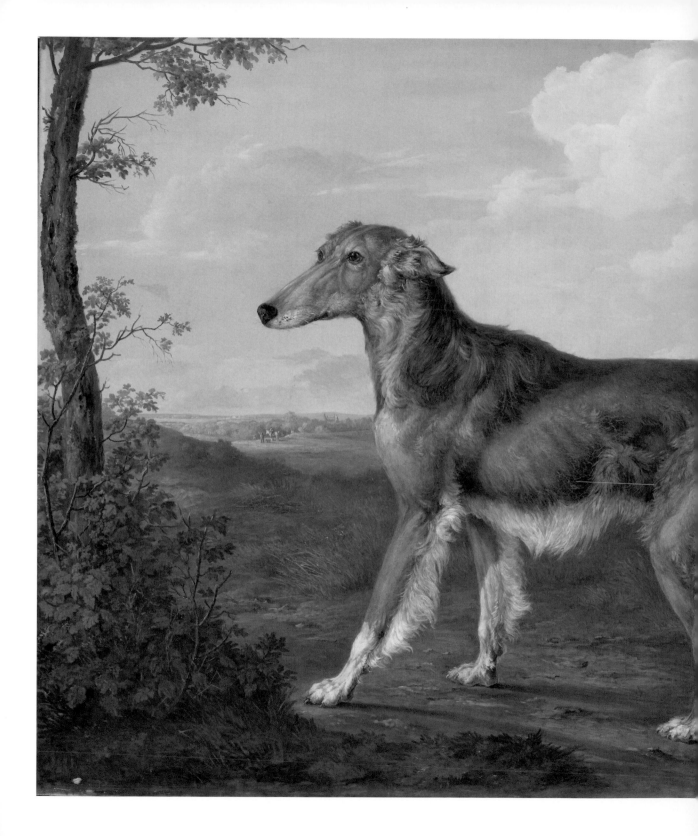

Siberian Greyhound
(ca. 1825)

by Jan Dasveldt

A Broholmer Dog Looking
at a Stag Beetle (1871)
by Otto Bache

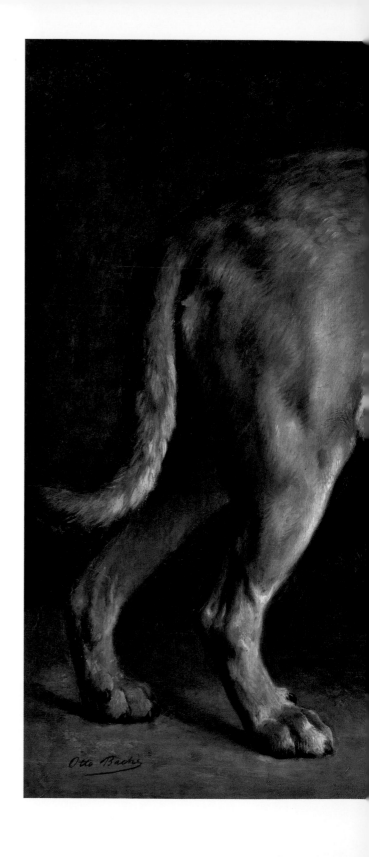

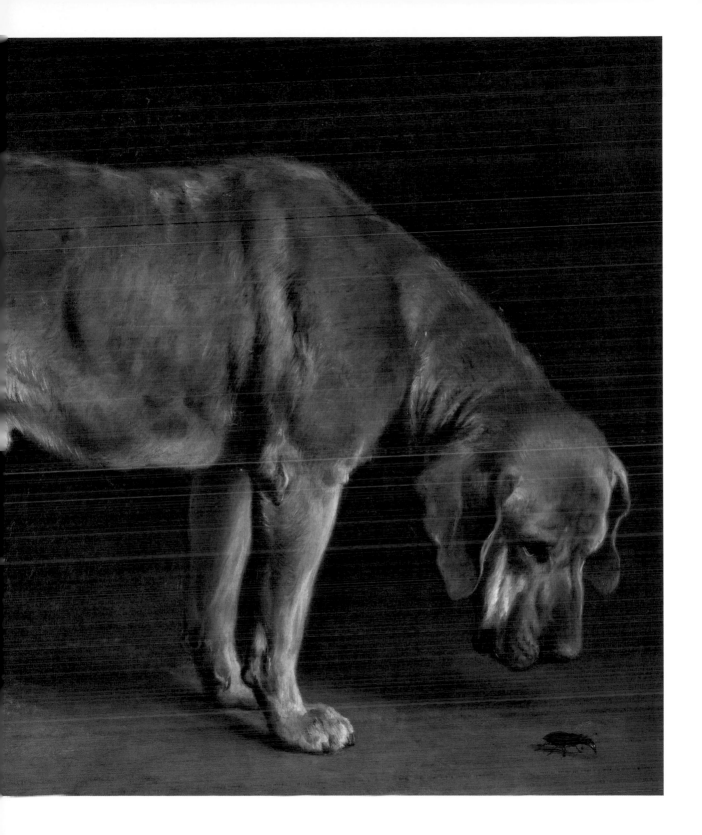

Dog (Canis lupus familiaris)
(1596–1610)

by Anselmus Boëtius de Boodt

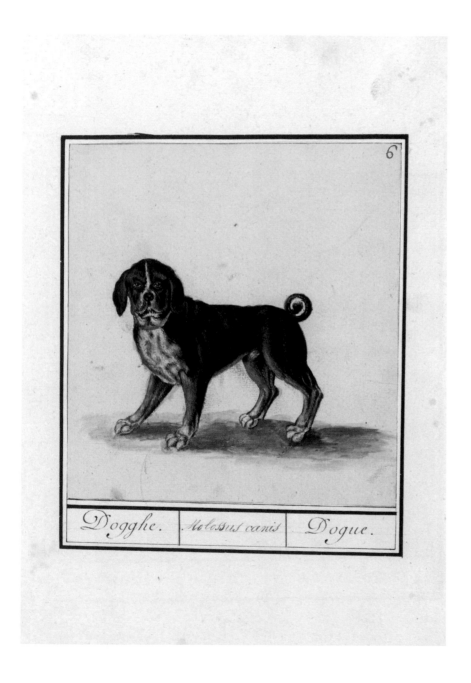

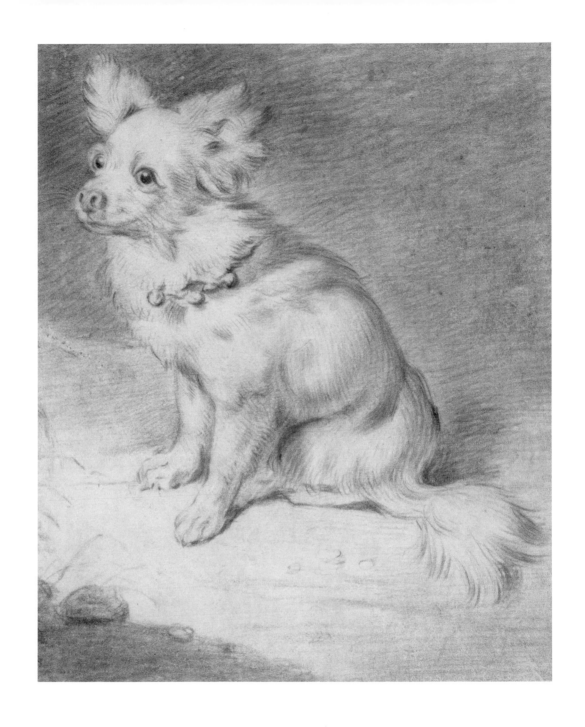

Seated Dog
(ca. 1650)

by Cornelis Visscher

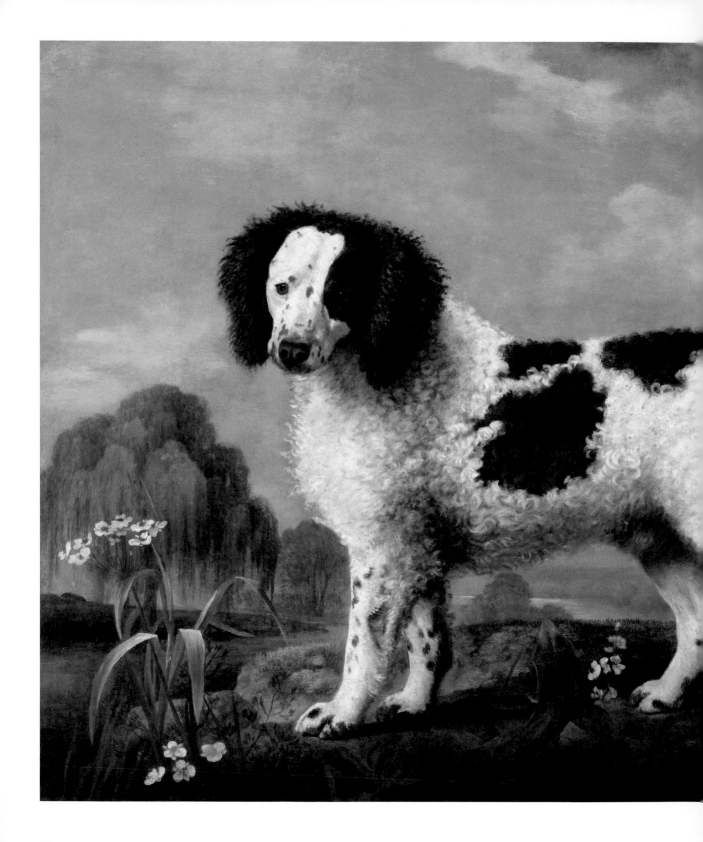

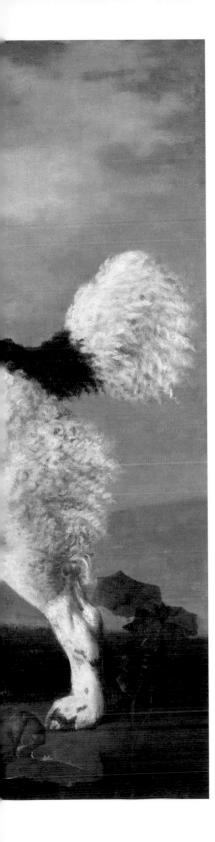

Brown and White Norfolk
or Water Spaniel
(1778)
by George Stubbs

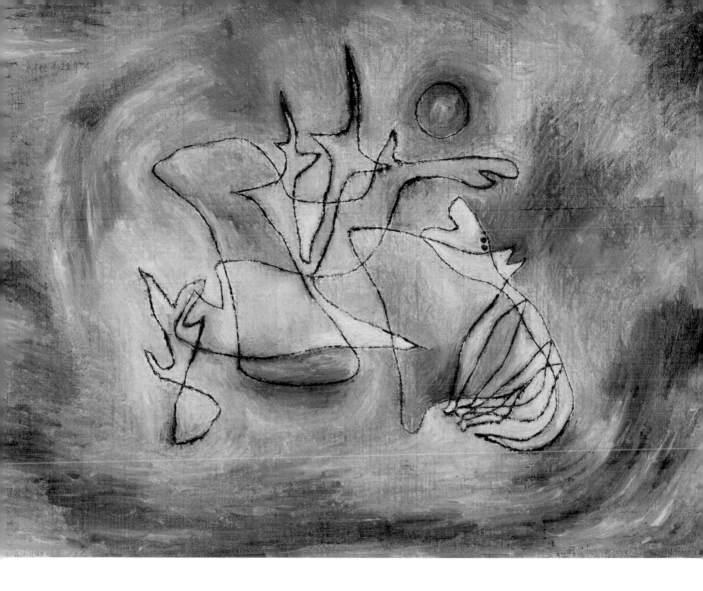

Howling Dog
(1928)

by Paul Klee

Dog and Cock
(1921)

by Pablo Picasso

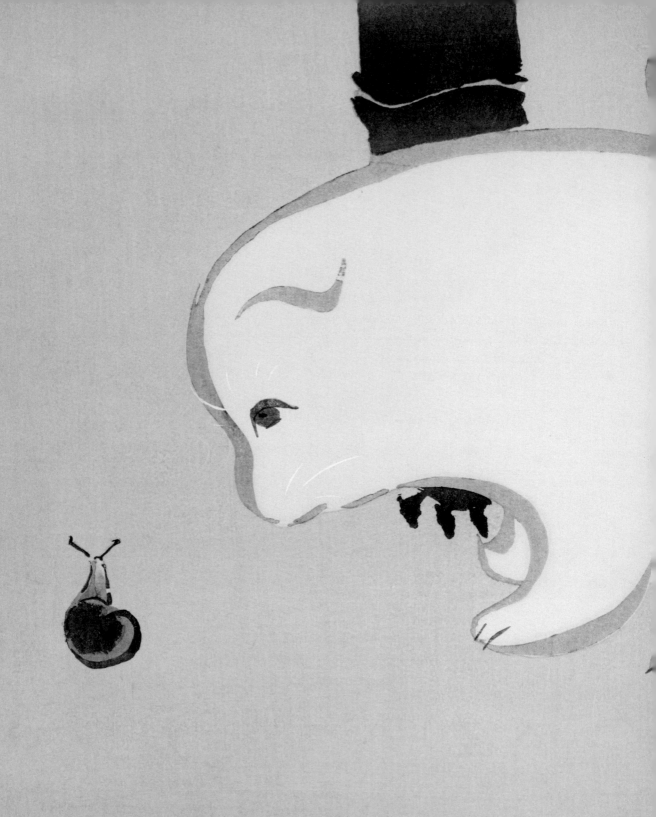

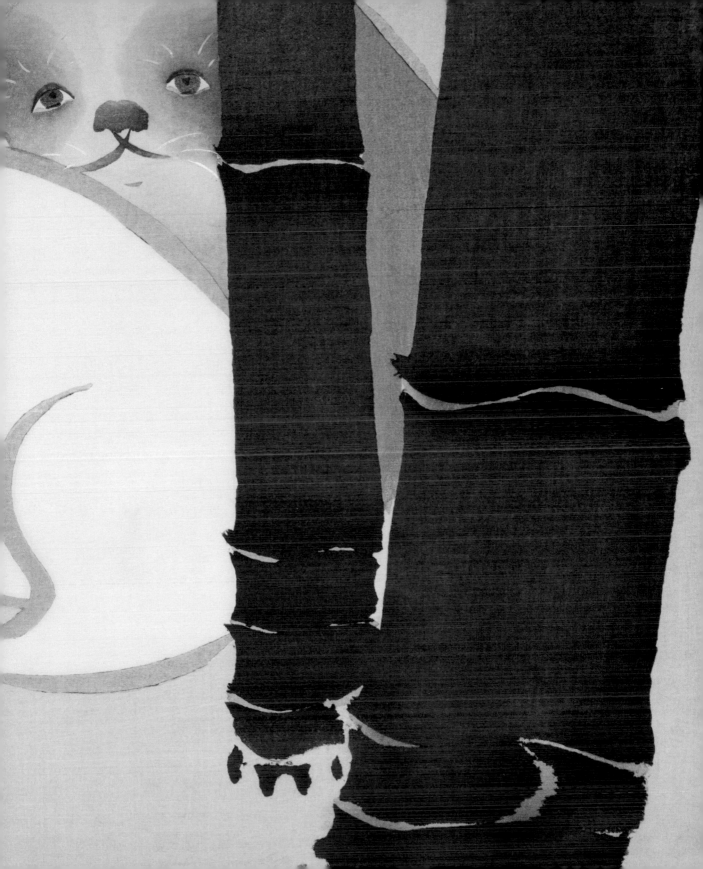

Dog and Snail from Momoyogusa –
Flowers of a Hundred Generations
(1909)
by Kamisaka Sekka

Three Dogs in an Alley
(ca. 1850)
by Charles B. Newhouse

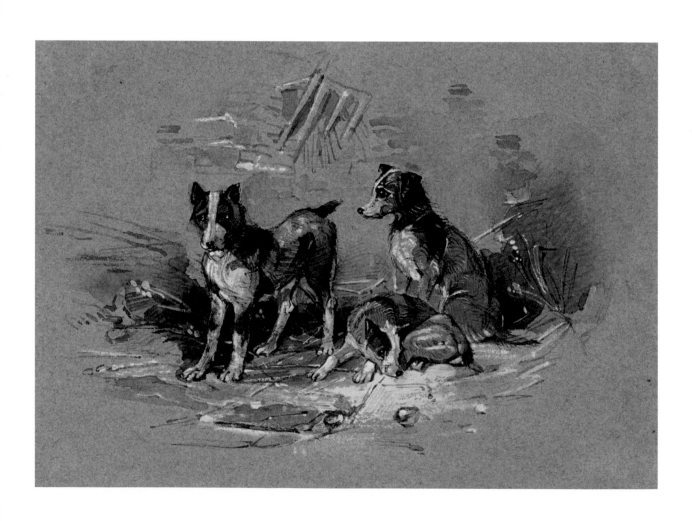

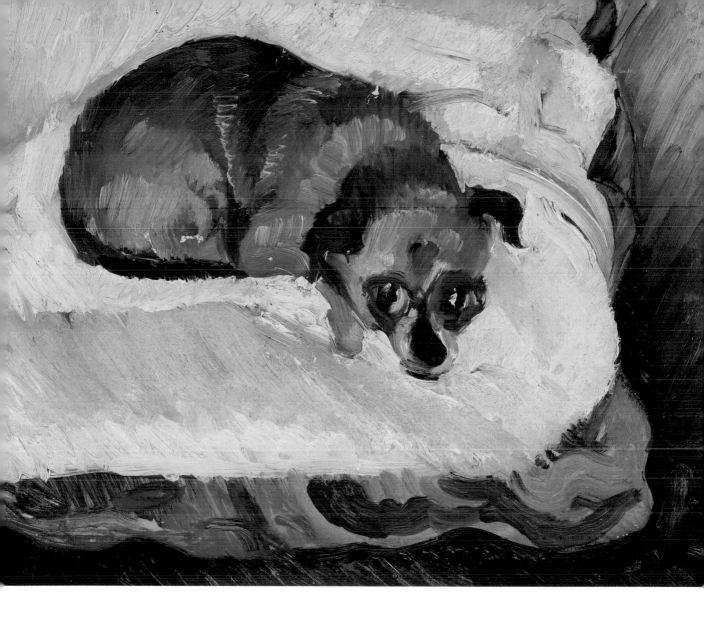

Lying Dog
(1914–18)

by Zygmunt Waliszewski

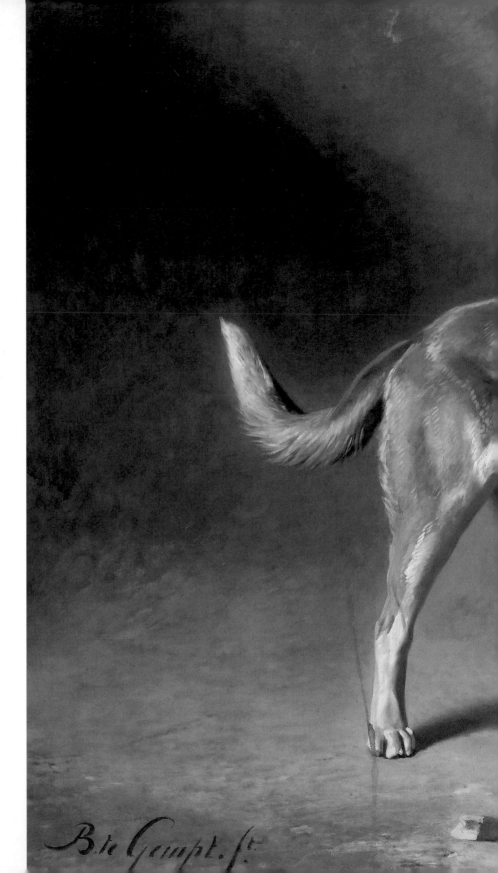

A St Bernard Dog
(1850–1879)

by Bernard te Gempt

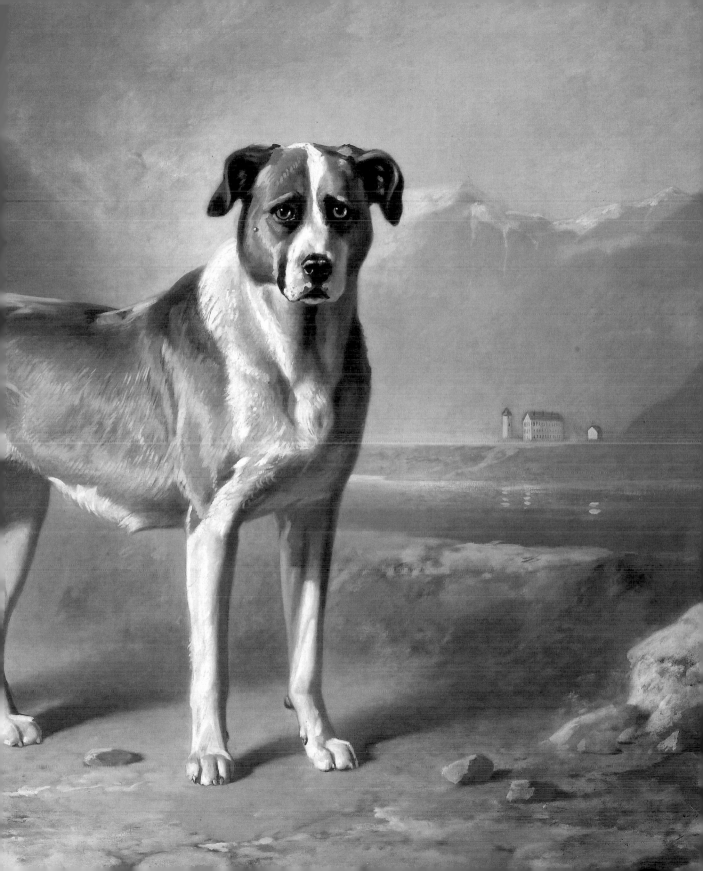

Published in 2023 by Smith Street Books
Naarm (Melbourne) | Australia
smithstreetbooks.com

ISBN: 978-1-92275-426-4

Publisher: Hannah Koelmeyer
Editor: Sophie Dougall
Text and image research: Patrick Boyle
Design and layout: Murray Batten
Printed & bound in China by C&C Offset Printing Co., Ltd.

Book 253
10 9 8 7 6 5 4 3 2